IMAGES
of America

SCITUATE

THE SCITUATE HISTORICAL SOCIETY

INCORPORATED 1917

THE CUDWORTH HOUSE
HOME OF THE SOCIETY

"The purpose of the Scituate Historical Society shall be to promote the study of local history and to preserve the antiquities of Scituate and those municipalities that were anciently a part of the town."

IMAGES
of America

SCITUATE

Scituate Historical Society

David Ball, Fred Freitas, John J. Galluzzo, and Carol Miles

ARCADIA

First printed in 2000.

Published by Arcadia Publishing,
an imprint of Tempus Publishing, Inc.
2 Cumberland Street
Charleston, SC 29401

Printed in Great Britain.

Library of Congress Catalog Card Number: applied for.

For all general information contact Arcadia Publishing at:
Telephone 843-853-2070
Fax 843-853-0044
E-Mail sales@arcadiapublishing.com

For customer service and orders:
Toll-Free 1-888-313-2665

Visit us on the internet at http://www.arcadiapublishing.com

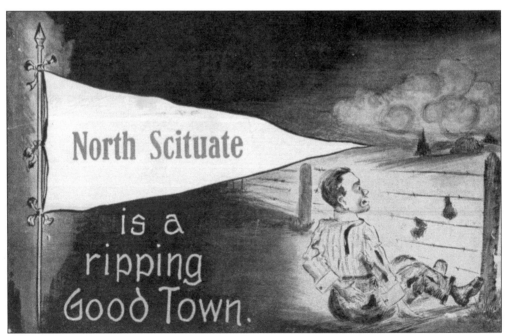

At the turn of the century, postcards said it all.

CONTENTS

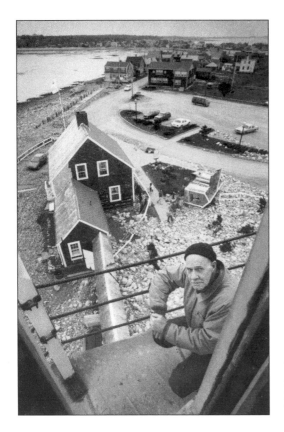

This book is lovingly dedicated to the memory of George Downton, keeper of Scituate Light from 1986 to 2000. "He kept a good light."

ACKNOWLEDGMENTS

The authors wish to thank several people, without whom the completion of this book would never have been possible. The trustees of the Scituate Historical Society have given complete support of the project since its conception, and their faith is much appreciated. Rodney Brunsell of Hanson and Leslie Molyneaux of Hanover recently discovered several Frederick Damon glass negatives at yard sales and shared them with the society; no book on turn-of-the-century Scituate will ever be complete without them. Edward C. Swift, Madeline Von Iderstein, Jo Schuman, Paul Miles, Jim Moran, Diane Vines, the U.S. Coast Guard, Russell Clark, Guy Hauman, the Hull Lifesaving Museum, Fred Field and the *Quincy Patriot Ledger* (for the photograph on this page), and the Estate of Henry Turner Bailey all provided important images. CWO Craig D. Bitler—commanding officer of U.S. Coast Guard Stations Point Allerton, Scituate, and Boston—surprised the authors with photographs of Scituate Coast Guard history. Fellow Arcadia author James W. Claflin of Northborough, Massachusetts, came through in a pinch with a photograph from the Vincent L. Wood collection of Life-Saving Service keeper Thomas Maddock. Robert Dillon loaned the Clifford Hutchinson photograph of the Scituate Sea Monster on page 87, and David Corbin's knowledge of the historical files at the Little Red Schoolhouse saved the day. To all of you, and anyone we may have missed, thank you. Your dedication to our local history is what keeps it alive.

INTRODUCTION

Scituate is one of the oldest towns in the United States. The town's rich and varied history has been well documented in several books, including Samuel Deane's *History of Scituate, Mass.* (1831), and *Old Scituate* (1921), compiled by the Daughters of the American Revolution, Chief Justice Cushing Chapter. Several other books are available that focus on specific aspects of Scituate's past. However, a photographic record of the town's fascinating past has never been published until now. *Images of America: Scituate* looks back into the town's incredible history, back to the very beginning of photography.

Early photographers quickly recognized that Scituate's unique blend of natural beauty, unusual events, and its interesting mix of people provided them with the ideal photographic backdrop. These photographers never realized they were providing a photojournalist record for Scituate residents to enjoy in the year 2000 and beyond.

Scituate was a town composed of many sections and villages. Even now, residents refer to their neighborhood by its long-standing name and take pride in the unique historic features found there. The original names of such sections as the West End, Mungo's Corner, Minot, Humarock, Sandhills, Cedar Point, Greenbush, Egypt, and Scituate Center continue to be used today. Many of the photographs in this book show these neighborhoods in an earlier time.

In the 1800s, residents made their living by farming, operating a small cottage industry, or by some activity involving the sea. Here, readers will see these people going about their daily lives. Because of the town's far-flung neighborhoods and the difficulty of travel before the advent of the automobile, numerous schools, churches, and public buildings were needed. Many of these buildings can be seen here as well.

Storms have always plagued mariners sailing past the Scituate shore. A private group called the Humane Society of the Commonwealth of Massachusetts began building houses of refuge along the coast, but more protection was needed. Two lighthouses helped—Minot's Light, the most dangerously situated light in North America, and Scituate Light. However, it was not until the U.S. Life-Saving Service opened two stations here that the loss of lives declined. Several photographs show the efforts of the lifesavers, and the early U.S. Coast Guard.

Probably more than anyone else, three individuals have shaped the appearance and fabric of this town during the 20th century. Colonel C. Wellington Furlong's tireless work to preserve open space along Chief Justice Cushing Highway is still appreciated by residents today. While Thomas W. Lawson's flamboyant style irritated many of his financial competitors, his legacy lives on. Just imagine Scituate without Lawson Tower or Lawson Common. Kathleen Laidlaw's

efforts to preserve Scituate history as president of the Scituate Historical Society from 1966 to 1996 are legendary.

We hope you enjoy this book and use it as a jumping-off point to learn even more about this proud and historic town.

—David Ball, Fred Freitas, John J. Galluzzo, and Carol Miles
for the Scituate Historical Society.

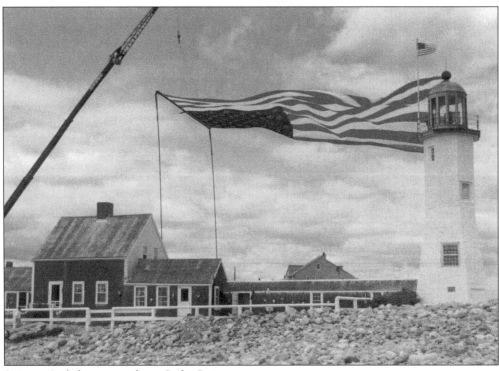

Scituate Lighthouse stands on Cedar Point.

One

VILLAGES

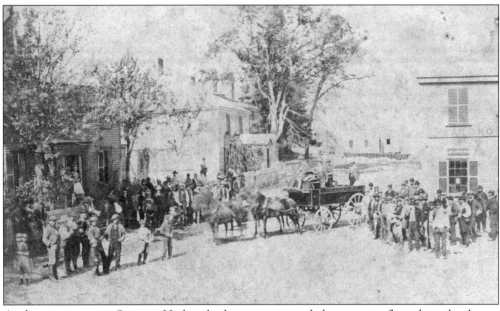

As the sun rises over Scituate Harbor, both continuity and change are reflected in a landscape of hills and marshes that have seen many such days over thousands of years. From the time of Scituate's last glacier until today, geography has played an important role in the town's settlement and development.

Fishing, the cliffs, the harbor, and forests of timber attracted the "Men of Kent" from England, and Scituate's European settlement was underway. For these first settlers, land division in their plantation began as lots were distributed, roads established, and marshland assigned. They built homes, farms, mills, and churches in different areas. Each separate part of Scituate began to develop its own distinct character as the town became a collection of widely dispersed villages. Until the 1950s, people associated more with the village where they grew up than with the town. So, join us for a look back at Scituate's villages. We begin with this view down Front Street, looking north, c. 1850.

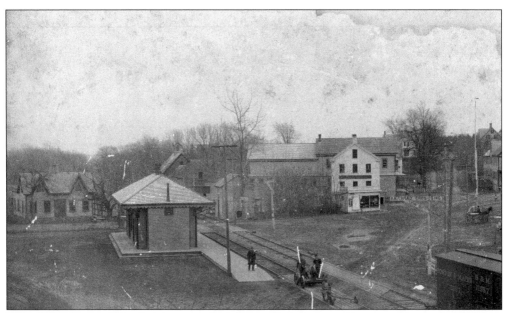

This 1890s scene of North Scituate, which was called Gannett Corners, takes us south down Country Way. From left to right are the residence of J.K. Gannett, the North Scituate Railroad Station, the icehouse of J.W. Morris, the Bailey Building, Seaverns Store, and the G.W. Bailey shoe store.

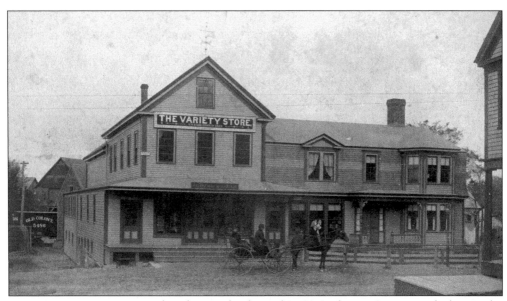

In 1867, Henry A. Seaverns bought out the firm of H.W. Bailey & Company, dealers in dry goods and notions at North Scituate. Enlarging the building to increase business, Seaverns managed the site for 20 years until 1887 under the name H.A. Seaverns & Company. That year, he joined in partnership with Sereno T. Spear, changing the name to Seaverns & Spear.

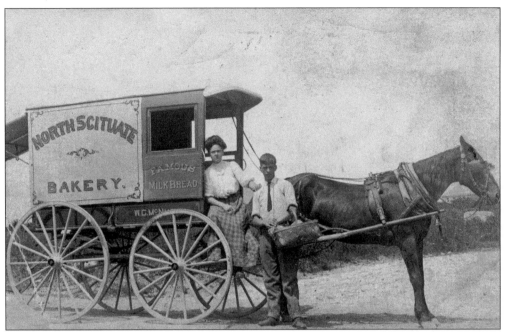

All business and general activity in the town depended upon the horse. Horse-drawn wagons carried children to school, farmers' produce to Boston, and brought meat, vegetables, fruit, ice, coal, and baked goods to people all over the town. In this picture, Mabel McNutt and Russell Knox hope to drum up some business on Gannett Road in 1910.

Even with the passage of time, North Scituate retained its charm, history, and commercial activity well into the new century. Although the style of cars and the names of businesses have changed—and even the trees have become smaller and fewer in number—we still can recognize our village of North Scituate in this image.

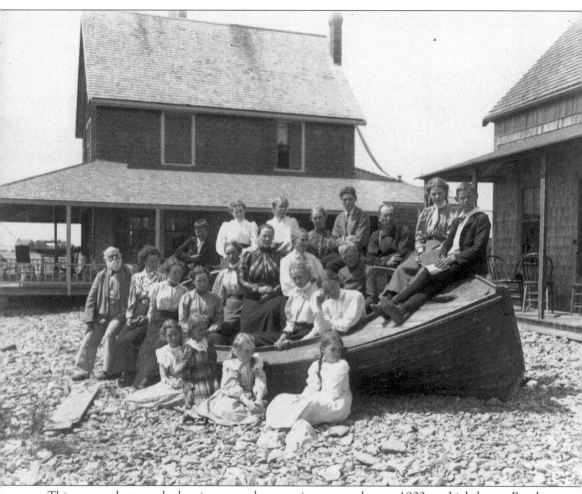

This group photograph showing several generations was taken *c.* 1900 on Lighthouse Road. Both houses in the background still exist. The house on the left stands at 82 Lighthouse Road. The house on the right—built by Tom Turner, a well-known local fisherman—stands at 84 Lighthouse Road. Turner mortared a jug into his chimney that would cause a rumbling noise in high winds. When Turner would awake to the distinctive sound, he knew would not go fishing in the morning. The jug can still be seen atop the chimney today.

Whether coming on family outings, church picnics, or just with a group of friends, the sands on the beaches of Scituate provided something for all. The sand, though, is what eventually caused the people of Atlantic City to build their famous boardwalk. They hoped to keep it out of the fancy shoes of visitors who came for the ocean air without the ignominy of grains of sand rubbing between their toes.

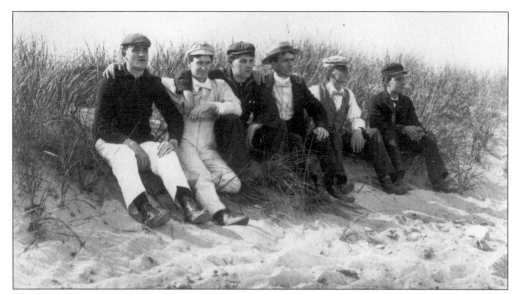

The boys of summer relax at the beach. One hundred years ago, Sandhills, like today, was a very popular summer destination. Families and friends could come here to enjoy the sun, sea, and fellowship. Walking through the dunes, swimming in the brisk, refreshing surf, or just lounging around, Sandhills had it all.

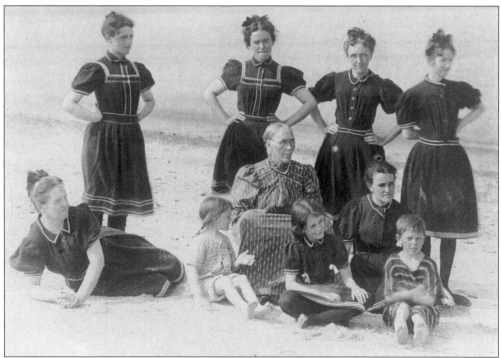

The girls of summer are enjoying the beach. Leisure was something new to Americans starting in the late 1800s. For the first time, average Americans could emulate the rich by partaking of the healthful benefits of a beach vacation. In this photograph, a family poses in beach attire at Sandhills. One has to wonder just how comfortable these women felt when their bathing suits were wet.

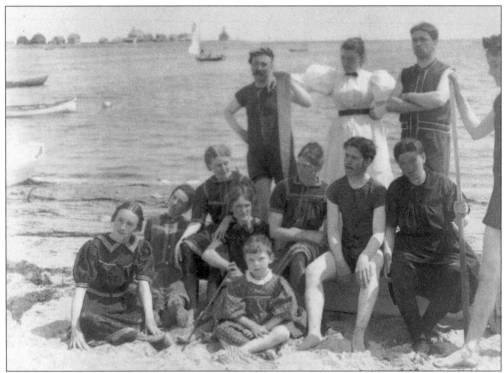

"By the sea, by the sea, by the beautiful sea; You and me, you and me, oh, how happy we'll be." By the late 1800s, people flocked to Scituate's beautiful beaches. Cottages would spring up all along Scituate's shore as people escaped the heat and conditions of city life. Here, in Sandhills, families enjoy their free time.

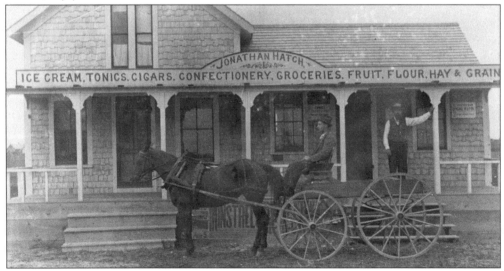

The local store was an integral part of many Scituate neighborhoods. It was not only a place to purchase staples, but a social center as well. This store at the south end of Sandhills boarded horses for nearby residents. The store also housed the Sandhills Post Office until the 1950s. Today, the horses and post office are long gone, but the store remains. Does anyone recognize Flynn's Market?

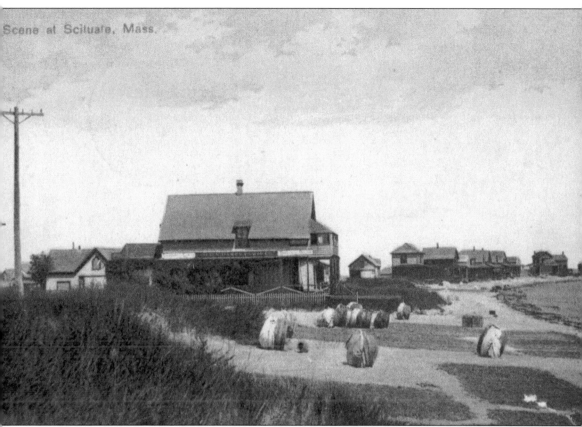

Scene at Scituate, Mass.

Frederick North Damon was born in 1870. It takes just a quick glance at his photographs on the last few pages to recognize that he was a talented photographer, but how did this ever come to be? We may never know. Other than his photographic accomplishments, not much is known about his life. We do know that he studied dentistry and attended the College of Physicians and Surgeons at Baltimore, Maryland. Whether or not he graduated is unclear. During his time at medical school, he contracted tuberculosis. Although his death certificate lists his occupation as dentist, it is unlikely he ever practiced. His family operated the "museum" on Jericho Road from 1895 to the 1920s. The museum had a large collection of Native American pottery, Civil War artifacts, shells, and stuffed birds. Because of his disease, Damon often traveled to the southwest seeking a dry climate, where he purchased many of these items for the museum. He struggled with his illness for 12 years, before dying in October 1907 at the age of 37. Damon Road was named for his family and the beach adjacent to the cottage is still known as Museum Beach by the locals.

The village at Scituate Center received its name because it was the town's center for education, government, and religion during the 19th and early 20th centuries. This picture captures all of these elements. A portion of the high school is on the right. Today, this section contains the media center, cafeteria, and computer labs of Gates Intermediate School. The town hall is to the left while the Unitarian church and Lawson Tower proudly adorn the background.

The village located "at the green bush" at the head of First Herring Brook is the site of the oldest mill in the United States, the Stedman-Russell-Stockbridge Gristmill. Nearby is Old Oaken Bucket Pond, made famous in Samuel Woodworth's poem "The Old Oaken Bucket," which appears in its entirety on page 125.

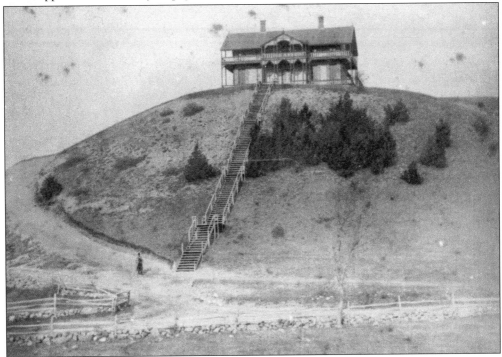

In 1871, George Eaton built a hotel on one of the Colman Hills, calling it the Colman Heights House. With the advent of the railroad, Scituate was beginning to attract summer visitors, but Eaton's hotel was never very successful. By the turn of the century, the hotel stood idle and the land was sold. Today, the recycling center building occupies this site.

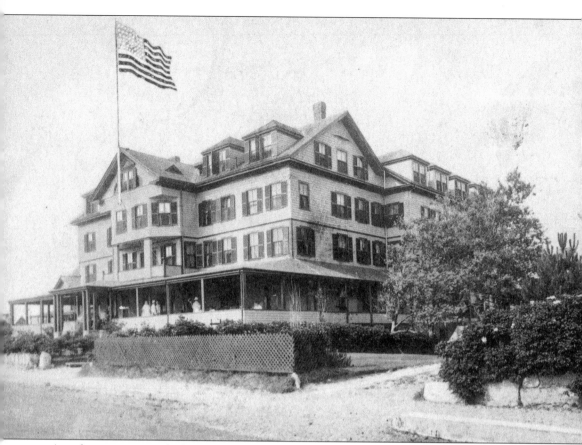

An advertisement in the book *A Trip Around Cape Cod*, published in 1898, described the Cliff Hotel at Minot as having 75 rooms along with "spacious piazzas and dining hall, and parlors with fire-places and steam heat, pure water supply, sanitary plumbing, electric lights and Public Telephone." How much would it cost for such extravagance? "Rates $2.50 to $3.00 per day, and special rates by the month or season." Over the next 76 years, 50 rooms were added, and many famous movie and television stars—including Zsa Zsa Gabor, Sid Caesar, Maurice Chevalier, and Imogene Coca—chose the Cliff Hotel as their resort getaway of choice. On Thursday, May 23, 1974—the day before it was to open for the summer—the hotel caught fire, drawing firefighters from ten surrounding communities to join their Scituate brothers in quelling the conflagration. By sunlight the next morning, a lonely chimney stood awkwardly above the charred remains of what was once known as the most luxurious hotel on the South Shore.

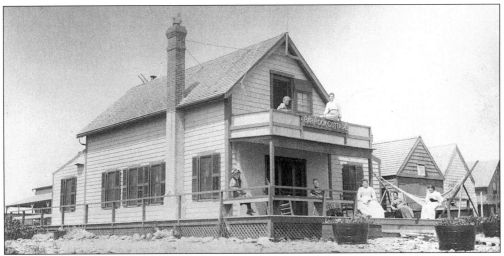

This cottage is one of the many that dotted Scituate's coastal villages. It was located in Minot on what was once the Hatherly farm. Minot, the Glades, and the land from Musquashcut Pond to Hollett and Border Streets was called Farm Neck by Timothy Hatherly. This land would be the home of many farms until the late 1800s, when they made way for summer cottages like the Bar Rock.

Taking one look out to the waters off Scituate at low tide, we can understand just why so many ships ran into danger approaching the coast. The Minot's Ledge area began claiming lives in 1693, when North River pilot Anthony Collamore lost a boat with all aboard, on what is now Collamore's Ledge. Neptune continued to wrest mariners to their death uncontested until the federal government succumbed to local pleas to build Minot's Ledge Lighthouse in 1850.

Trees, brooks, swamps, and pastures are the main landforms that define the West End, but one prominent feature that everyone in town knows is "Itchy's on the Square." Named after a store owned by Israel Cohen, this unique landmark is a symbol of the West End. Recently, there was concern regarding traffic safety at this well-known intersection, and a movement was made to remove the pole. However, local residents rallied together and saved their symbol.

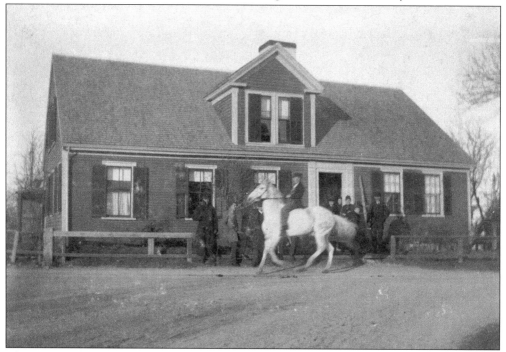

The Ray Litchfield Homestead dates back to the 17th century, and has undergone many changes since its original construction. Looking carefully at the picture of Itchy's, we can see the Litchfield home.

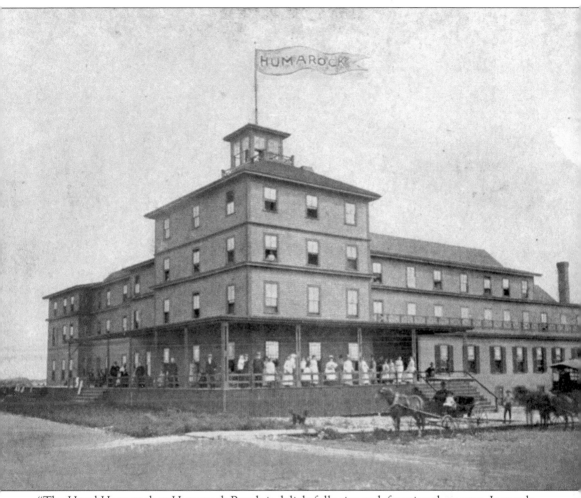

"The Hotel Humarock at Humarock Beach is delightfully situated, fronting the ocean. It stands right at water's edge on a smooth sandy beach, which stretches away for miles in a graceful curve. From its broad and sandy piazzas, one may snuff the cool salt air, while the eye is rested by the swell of the ocean waves. Landward and across the North River the pretty hills of Marshfield are in view, giving a combination of seaside and mountain resort rarely met." So says an advertisement for one of the largest hotels in Scituate at the turn of the century. It boasted that it was "lighted" by gas, had electric bells in every room, and even had a telephone. For attractions, it claimed to have spring water, cuisine and service first class, bowling (with three alleys located in a separate building), and a hall for billiards. The hotel was 30 miles from Boston and only 1 mile from the railroad station at Sea View (Marshfield) over a good road with beautiful country scenery. What more could you ask?

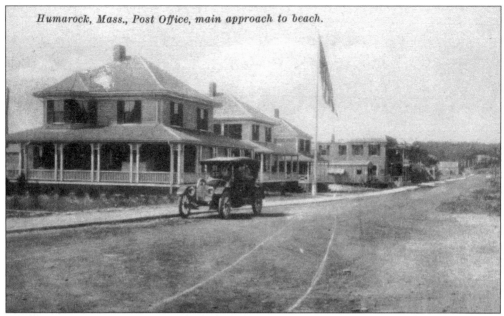

Humarock, Mass., Post Office, main approach to beach.

Looking westward down Marshfield Avenue *c.* 1910, we see that the Hotel Humarock has burned down and has been replaced with the buildings lining the left side of the road. The Fourth Cliff Land Company, the original developers of Humarock, had broken up by then, and individual house lots were being sold and built upon.

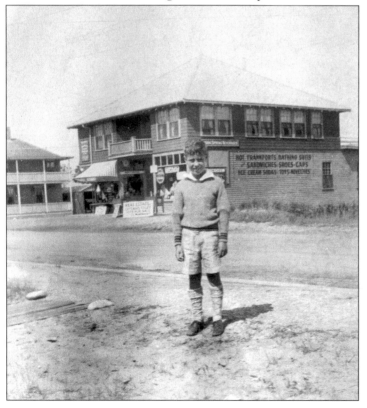

An unidentified boy stands on Marshfield Avenue in this 1930s view looking northwest. In the background stands the building that is currently Christina Brown's Humming Rock Gifts store. Peeking around to the left of the building, one can make out the old stable that went with it, even by that time a holdover from the age of horses and buggies.

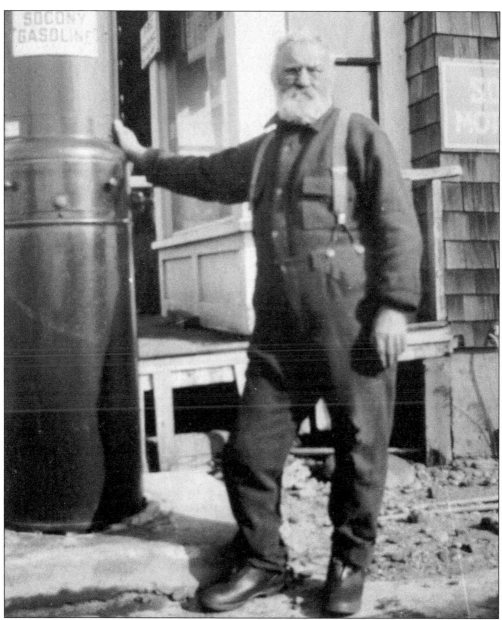

Daniel Webster Clark was one of the best-known residents of Humarock. Born in Vermont, he came to Scituate in the early 1900s. With a keen eye for development and an interest in real estate, he saw the possibilities of Humarock and set out to build a number of houses, inducing others to join him. Soon, he had almost single-handedly transformed the area into one of the best-known resorts along the South Shore. To supply the thriving community, he established a general store, and built a wonderful trade. For the last 17 years of his life, from 1913 to 1930, he served as the local postmaster. In a time when most folks chose to summer *here* and winter *there*, Clark firmly planted his roots in Humarock, making it his year-round home. Whenever a civic improvement project was proposed and he felt it would benefit Humarock, he was right in the forefront to push for its implementation. Today, his descendants remain in the area, ably carrying on his sense of civic pride and his ability to instill it in others.

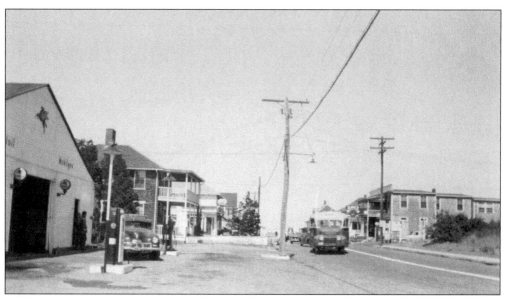

Folks passing over Humarock Bridge first come upon Covell's gas station on the left, occupying the site where the Hotel Humarock's stables once stood. Humming Rock Gifts is next, and next to that (across Central Avenue) is the Atlantic & Pacific Tea Company. Clark's General Store is on the right, complete with a gasoline pump out front. Note the severely warped telephone pole in the center.

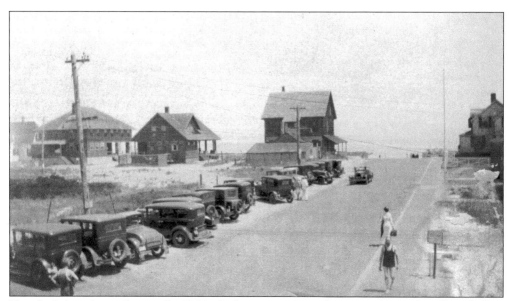

Very little has changed since the 1930s. In fact, some things have not changed at all, including the line of cars parked at left for a day at the beach. Why is there no police officer checking to see if they have stickers?

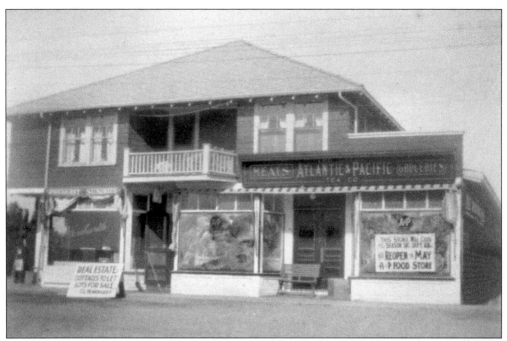

Yes, Humarock had its own A&P. It stood across the street from Clark's General Store at the intersection of Marshfield and Central Avenues. In an age when the anti-trust laws had already broken up the monopolies of the robber barons, Clark had some real competition. Not only had the Atlantic & Pacific Tea Company moved in on his grocery business, but the sign on the ground to the left shows they wanted a piece of his real estate action as well.

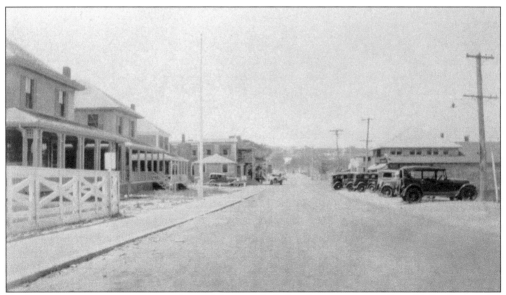

Looking west as we prepare to leave Humarock behind, we can see the old bridge in the distance and Holly Hill behind it. To take one last spin through the town square, we would have to go behind the buildings on the left. We would then go over the bridge to wind our way back to the harbor.

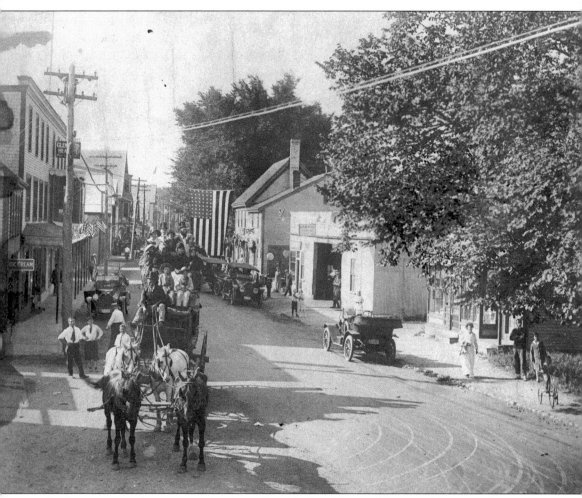

And so we return from our opening jaunt through the villages of Scituate, having made stops in North Scituate, the Sandhills, Scituate Center, Greenbush, Minot, the West End, and Humarock. Back to Scituate Harbor (shown 60 years later), we stumble onto a parade, a patriotic celebration done up the way only the people of Scituate can do it. After a half century of progress and transformation, the harbor retains its quaintness. An advertisement for the Hotel Stanley in 1898 said that "for bathing, boating and fishing, it is without an equal on the New England coast, and its beautiful country drives and many rolling hills give it a peculiar attractiveness as a summer resort. Its waters are teeming with the many graceful spritsail boats of fishermen and the gatherers of Irish moss, and the sand beaches are dotted with their cottages and moss houses".

We have only just begun our trip through the historic streets and homes of Scituate. There are yet more people to meet, more households to visit, and stories to be told. We have not even set foot in Thomas Lawson's Dreamwold or seen a glimpse of Scituate Lighthouse. Let's continue.

Two
PERSONALITIES

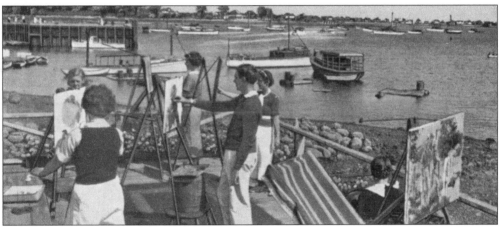

Perhaps the most interesting stories in Scituate's history are the biographical sketches of the inhabitants and of those folks who made Scituate their second home. While the Irish mossers of Scituate Harbor quietly worked away at their chores in the early 1870s, they noticed a steady influx of outsiders beginning to discover the joys of fresh breezes off the Atlantic under a warm July sun. The harbor area soon became a gathering place for people participating in the arts. As early as 1860, Thomas William Parson, a poet and the first American translator of Dante, lived in the house at the corner of Meeting House Lane and Kent Street with his brother-in-law, George Lunt, who was a well-known Boston lawyer, author, and editor. In 1870, a theatrical troupe calling itself the Boston Recreational Group camped on First Cliff. The following year saw summer encampments on Second Cliff (where no houses had yet been built) of the Howard Associates, who stayed for six weeks and gave two entertainments while in town. Their winter home was the Howard Athenaeum, later called the Old Howard Burlesque Theater. From a long list of visitors and residents alike, Scituate can boast of Will Irwin, Ralph Frye, Jacques Futrelle, Samuel Hopkins Adams, Mowry S. Kingsbury (nom de plume: Cyrus Tucker), Josephine Lewis, Theodora Thayer, Alice Beckington, Mabel Stuart, Josephine Hull, and Sinclair Lewis, all famous for their artistic achievements. This scene on Dock Street shows some members of the artist colony transferring the beautiful Scituate scenery from nature to canvas.

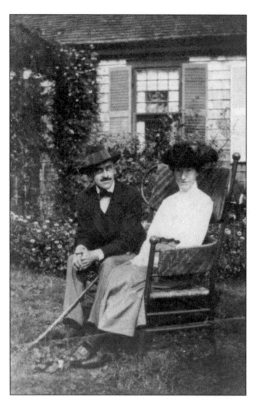

One of the artists who came early to Scituate was Thomas Buford Meteyard, who with his mother, Marion Lunt Meteyard, summered on Kent Street with his grandfather, the Honorable George Lunt. In this *c.* 1900 photograph, Meteyard sits with his wife, Isabel Montague Barber.

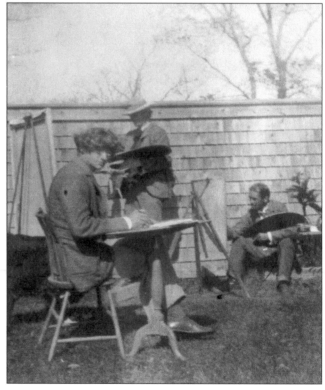

The artist is at work with his friends, poet Bliss Carman and fellow artist Dawson Dawson-Watson. Carman visited so frequently that he had a room assigned to him that had one wall hand-decorated with a life-sized satirical mural of Meteyard's friends.

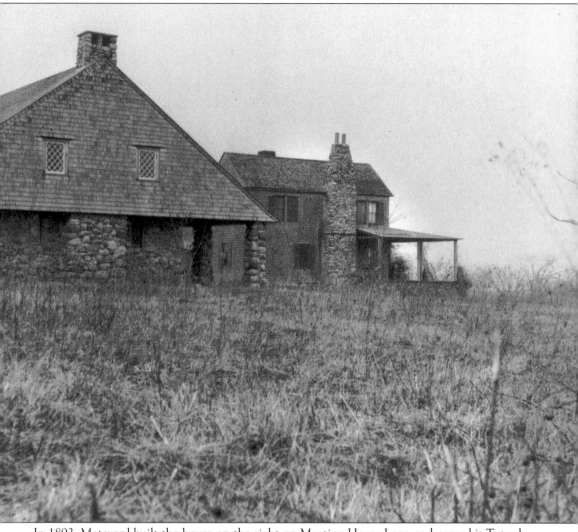

In 1893, Meteyard built the house on the right on Meeting House Lane and named it Tetsudo (or "tortoise" in Latin), which he used as his personal logo. Next to it, on the left, he built a large and airy studio where he could work undisturbed. Tetsudo was presided over by his mother and was the scene of many memorable "teas" and "open houses" every week. These social occasions were so prestigious that people flocked to them. Tetsudo burned down in 1910 when the Meteyards were in Europe. It was a total loss; nothing of the fine furnishings and mementos was saved. He never again stayed for any length of time in Scituate.

Peggotty Beach was always a popular spot in the summertime, but people have often wondered how it got its name. George Lunt's niece Francesca supposedly gave Peggotty Beach its name from the nurse in Charles Dickens's *David Copperfield*.

Nearby lived Doris and George Hauman, famous as the illustrators of the favorite children's book *The Little Engine That Could*. They illustrated many book and music covers and founded the Arts and Crafts Society of Lexington, Massachusetts. Doris taught art at Derby Academy in Hingham for 14 years.

Explorer, painter, writer, university professor, lecturer, soldier, publicist—who would think that this mild-looking man would have so many impressive titles after his name? C. Wellington Furlong could apply all of these descriptions to himself and add the title of World Bull Riding Champion at the Pendleton Roundup. *Let 'Er Buck*, published in 1914, vividly describes those amazing days. During World War I, Furlong worked in intelligence for the U.S. Army and for that received the Distinguished Service Medal and the Croix de Guerre. His exploits in 1907–1908 exploring Tierra del Fuego and Patagonia resulted in his book *The Cold Land of Fire*, published shortly after his return. Loving Scituate, he was an early advocate of conservation and space planning. A proponent of any cause that he deemed good for the town, he often enlivened town meetings with his forceful and frequent comments.

Scituate would look vastly different today had it not been for the untiring efforts of Frederick T. Bailey. At various times, he was a member of the school committee, selectman chairman, assessor, a member of the planning board, and chairman of the Plymouth County Commission. In 1933, he envisioned a grand plan for parks, roads, and future sewers, entitled *Looking toward Dawn*. Had this plan been implemented, Scituate would have had parkways, recreation lakes, a wide and beautiful Front Street, and controlled development, with a sewerage plan in place. Still, the streets are lined with trees, and thoughtful zoning has kept business and residential areas separate. Bailey also designed the Hatherly School on Country Way in 1896, his "first architectural success." It was here that Sarah Tilden Bailey started her teaching career.

As the first art teacher in Scituate, "Aunt" Sally Bailey worked without pay for one year. Ten small schools in Scituate and individual school houses in Hingham and Cohasset comprised her biweekly itinerary. She was so successful that the following year (1898) the town voted her a salary of $200 "to make drawing a permanent study, as required by law." An innovative teacher working on short funds, she used objects from nature for the children to draw. On one occasion, she brought a large Hubbard squash to school and proceeded to break it with an ax. She then gave a piece to each child and them to draw what they saw.

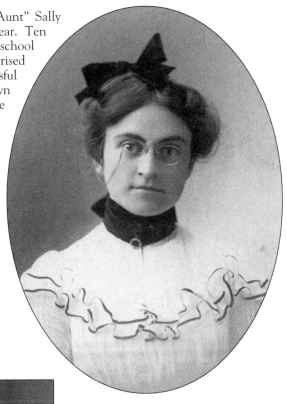

Always a bit of a tomboy, a favorite family story has Sally Bailey at an early age responding to a Christmas present inquiry with a request for "a pair of hip boot waders and a gun." After she married Moses Lowe Brown in 1902, her teaching career ended (married ladies were not allowed to be teachers). However, she wrote for various newspapers, directed pageants, and supported the women's suffrage movement. On her 100th birthday in 1977, the selectmen proclaimed October 20th as Sally Bailey Brown Day. As Bailey had been the town's first art teacher, the school committee also established the Sally Bailey Brown Scholarship Fund for Art.

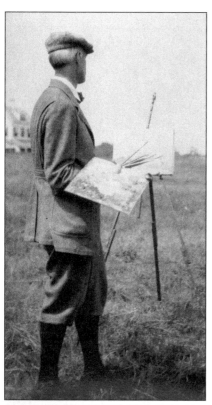

Painting and teaching were all-consuming passions for L. Walter Sargent, shown working at his easel in Plymouth. His paintings could be seen hanging in the Chicago Art Institute, Corcoran Art Gallery, Pratt Institute, the New York Academy of Design, and several other distinguished locations. Art educators and others interested in color theory still look to his most enduring work, *The Enjoyment and Use of Color*, for inspiration. Ernest H. Wilkins, president of Oberlin College, said of him, "His teaching, like his painting, was shot through with sunlight. He was, indeed, a great man and a beloved minister of sunlight."

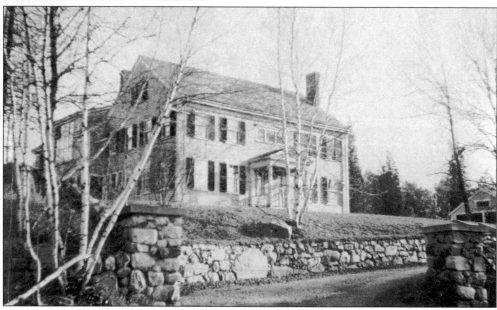

Sargent's home, Gleamwood, which was located on Booth Hill Road, overlooked Morris' Pond. Teaching at the University of Chicago for many years, he arranged his schedule so that he taught during the winter and summer, leaving spring and fall to spend in Scituate, where he could paint the colors of nature and refresh himself with study. His advisory capacity at the Carnegie Education Foundation was greatly prized.

One resident who did not make a splash or even make his presence known was noted engineer and inventor, E. Coverly Newcomb. Not only did he help develop the first automobile built in Massachusetts at age 19 (working with the Holter-Cabot Company of Boston), but he later helped develop both steam and gasoline engines, largely with the American Locomotive Company and then with the Simplex Auto Company in New Jersey. The Studebaker Company also enjoyed his expertise, after which the Scituate man offered and sold some of his patents to the General Motors Company, most notably a super-efficient carburetor for the gasoline engine. (He adapted this carburetor to his personal car, getting unbelievable miles per gallon.) His experiments with the diesel engine resulted in its successful development. He was the inventor and designer of electric motors, generators, power plants, automotive devices, electric oil burners, two-cycle engines, and the balancing system on diesel engines.

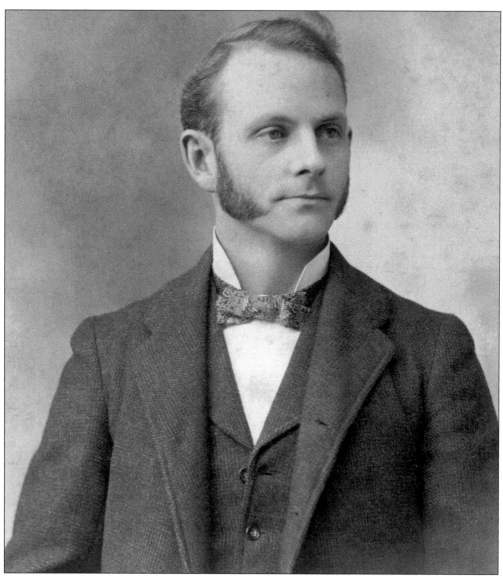

Where would the world of art education be today without Henry Turner Bailey? His zest for life was remarkable. The words exuberant, enthusiastic, entrepreneurial, premier art educator, author, magazine editor, and naturalist were all applied to him. Interested in everything and with excess energy to pursue his dreams, Bailey graduated from the Massachusetts Normal Art School in 1887 and became the first supervisor of drawing in the state (and, indeed, in the United States). He went on to become dean and later director of the Cleveland School of Art. His efforts through the *School Arts* magazine (still in existence today) influenced and directed many art teachers. He was also founder and director of the John Huntington Polytechnic Institute in Cleveland. At one time, the Thomas Cook Company enjoyed his services as a stimulating art historian-lecturer and as a guide on their European tours. When on the lecture circuit, which he loved, he regularly attracted large and enthusiastic crowds. In his busiest year, he lectured 400 times. As a representative of the United States, he was a delegate to six International Art Congresses: Paris (1900), Berne (1904), London (1908), Dresden (1912), Paris (1926), and Prague (1928).

Henry Turner Bailey and Josephine Litchfield, his life-long love, became engaged as soon as they graduated from high school at age 16. Each worked in order to save money for their dream house, designed by Henry, which they named Trustworth. They moved it into on their wedding night seven years later.

As a naturalist with an inquisitive mind, Henry Turner Bailey tried his hand at many things. Mushrooming was a favorite pastime, and he would whip up mushroom recipes for guests and family alike. He loved Scituate and served as town moderator for many years. He was instrumental in the founding of such institutions as the Peirce Memorial Library, Hatherly Country Club, Scituate Historical Society, Konihasset Boat Club, and the South Shore Nature Club.

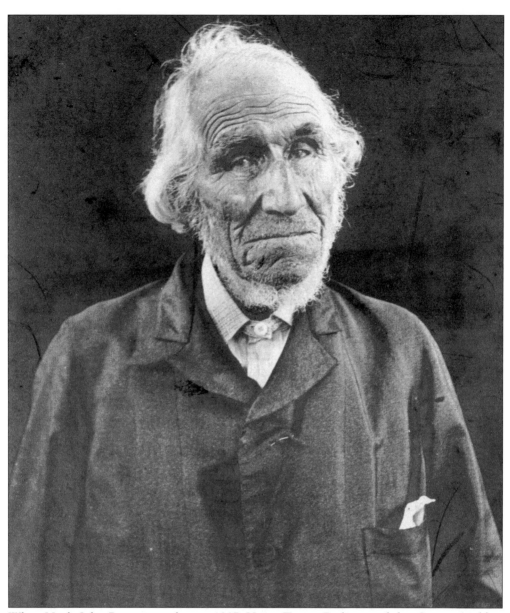

When Uncle John Brown passed on in 1907, Henry Turner Bailey noted that Scituate's oldest resident had lived under 24 of the first 27 presidents and voted for 20 of them. Born on July 14, 1808, Brown took up the caulking trade as a youth, walking 30 miles to Boston twice a week because he was too poor to afford carriage fare but still wanted to spend weekends at home. He eventually settled into a job on the North River and married Clarissa Cook, raising four boys, two of whom perished in the Civil War. As he aged, he became the mascot for the George W. Perry Post No. 31, Grand Army of the Republic, leading the Memorial Day parade into his 90s, "swinging along at a gait that makes many of the younger veterans hustle." Whether he was walking from Sherman's Corner to the Harbor Methodist Church every Sunday, passing the collection plates, or visiting friends at First Cliff, Brown remained one of Scituate's most beloved and visible citizens until the day he died at age 98. Simply put by Henry Turner Bailey, "No man in Scituate can remember when Uncle John Brown was not there."

"Independent as a hog on ice" could have been a term easily applied to Percy Mann during his seemingly endless time on this earth. He is shown here near the end of his life, resting after scything the field behind him. Percy was fiercely independent and stood for no interference in his daily routine.

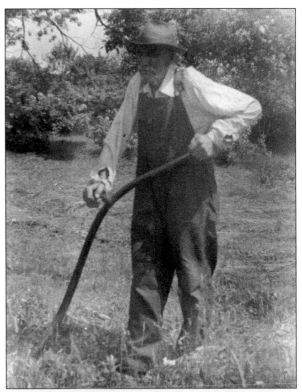

To understand Mann's personality, one need only see the rusted and derelict remains of his automobile, which he parked under a tree and never drove because of a tax that he considered an infringement of his rights. Today, the Scituate Historical Society maintains the Mann Farmhouse as a historic site, sharing property with the beautifully kept Wildflower Garden, tended by the Scituate Garden Club.

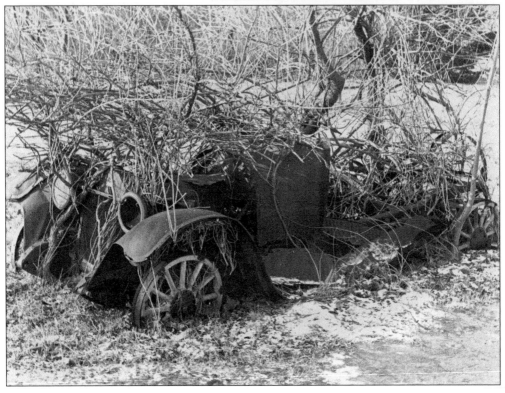

Scituate is a town rich in a history that we can all enjoy more fully thanks to the tireless efforts of Kathleen Laidlaw. While she did not have roots reaching back generations in this town, she might as well have, given her deep love of its history. For 30 years, she was the president of the Scituate Historical Society and an activist committed to the preservation of the town's history. Soon after becoming president, she went before the town meeting to secure funds for repairs at Scituate Light, which was in decrepit condition. Winning that battle, she went on to the restoration of the Mann Farmhouse, the purchase of the Old Oaken Bucket Homestead, the reshingling of Lawson Tower, and the opening of the Scituate Historical Society headquarters (now called the Kathleen Laidlaw Historical Center). She was also greatly committed to the education of children and reveled in telling the fascinating stories of Scituate's rich past. Thousands of school children benefited from her efforts, and that is her true legacy.

Three

LIGHTHOUSES AND LIFESAVING

In 1787, the Humane Society of the Commonwealth of Massachusetts selected three sites along the coast on which to build its first houses of refuge for lost mariners: Lovell's Island in Boston Harbor, Nantasket Beach, and Third Cliff in Scituate. In 1807, the society placed America's first shore-based lifeboat up the coast in Cohasset. Three decades later, they launched a second wave of boat-building, ultimately establishing a series of five lifeboat and mortar stations in Scituate: at the Glades, near Minot's Light, on North Scituate Beach, at Sandhills, and at Scituate Harbor. The federal government patterned its U.S. Life-Saving Service on the all-volunteer system of the humane society, and in 1915 the U.S. Life-Saving Service merged with the Revenue Cutter Service to become today's U.S. Coast Guard.

In 1811, Scituate Light shined out for the first time, guiding mariners into the harbor and up the coast toward Boston. Increasingly, however, sailors confused the Scituate and Boston beacons, adjusting course for one or the other and subsequently running their vessels into danger. In 1850, the Light-House Establishment decommissioned Scituate Light in anticipation of the construction of a new light on Minot's Ledge to the north. When that light fell into the sea a little more than a year later, the government relit Scituate Light.

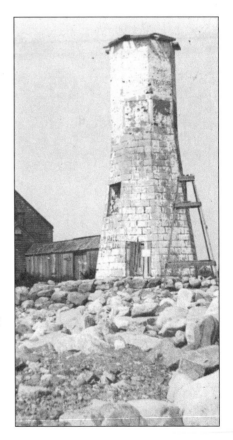

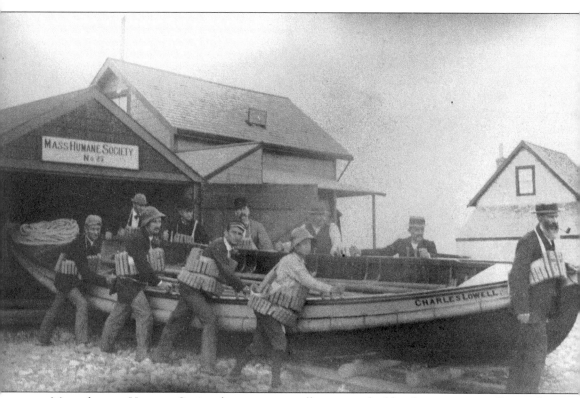

Massachusetts Humane Society boat crews usually consisted of local mariners—in Scituate's case fishermen, lobstermen, or mossers—anyone who could handle a small boat on a rough sea. To be able to call oneself a volunteer lifesaver became a badge of honor, as the citizenry of the Victorian age heartily recognized the selfless actions of men and women who risked their lives to save others. The humane society named each of its lifeboats for their longtime officers, trustees, and supporters. The volunteers at Jericho Road performed their rescues aboard the *Charles Lowell.* Reverend Dr. Lowell succeeded Reverend Dr. Simeon Howard as minister of the West Church in Boston. Lowell served as a humane society trustee from 1814 to 1816, as corresponding secretary from 1817 to 1828, as second vice president in 1829, and as first vice president from 1830 to 1834. Along the way, he helped establish the McLean Asylum for the Insane and the Boston Lying-In Hospital.

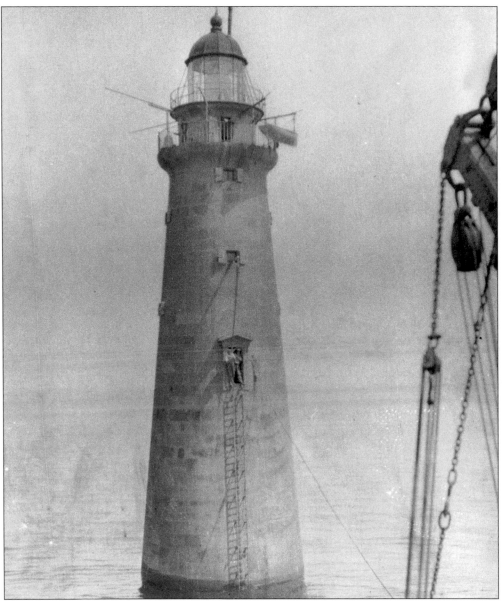

To replace the original Minot's Lighthouse, the federal government set about its most ambitious project to date. Superintending the construction of a lighthouse designed by Army Corps of Engineers Gen. Joseph Totten, Capt. Barton S. Alexander began preparing the site in 1855. Two years later, a "stone sloop" owned by Captain Nichols Tower of Cohasset carried the first of more than one thousand interlocking Quincy granite blocks to the ledge. A steam engine lifted the blocks into place as the tower reached higher through the summers of 1858, 1859, and 1860. In September 1860, light from the 114-foot sentinel brightened the night sky for the first time, and again Scituate Light was doused. In the 1890s, the lighthouse adopted its famous 1-4-3 (or "I love you") flash pattern and has since been known as "Lover's Light." Love, however, was the farthest thing from the minds of these two keepers as they awaited fresh supplies on the arrival of the lighthouse tender *Lotus*, from which this picture was taken in the late 1930s.

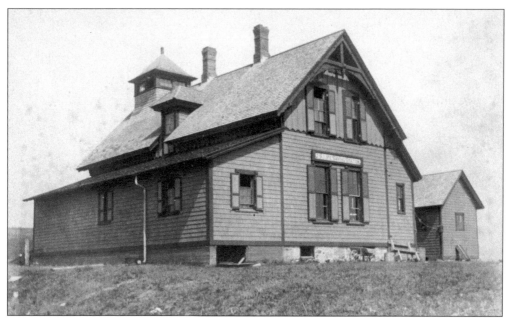

In 1879, the U.S. Life-Saving Service built the Fourth Cliff station, an 1876-style that is shown here after many modifications. It was the only one of its kind on the Massachusetts coastline. At first, keeper Frederick Stanley's surfmen patrolled southward to the mouth of the North River and northward across a barrier beach toward Scituate Harbor. The station burned to the ground in 1919, leaving the lot at the southern foot of the hill that remains empty today.

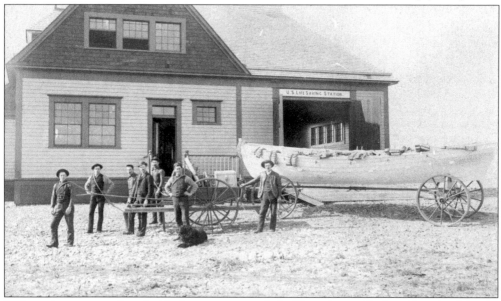

Each station came equipped with the necessary tools for lifesaving, as displayed here by the crew of the North Scituate station: lifeboat, cork life jackets, beach cart with breeches buoy, faking box, A-frame, Lyle gun, projectiles, hawsers, and seven able-bodied young local seagoing types to act as surfmen. When you added one grizzled veteran of the waves who knew the coastline like nobody else around, you had a bona fide U.S. Life-Saving Service crew. Dogs, cats, and horses served faithfully as station mascots.

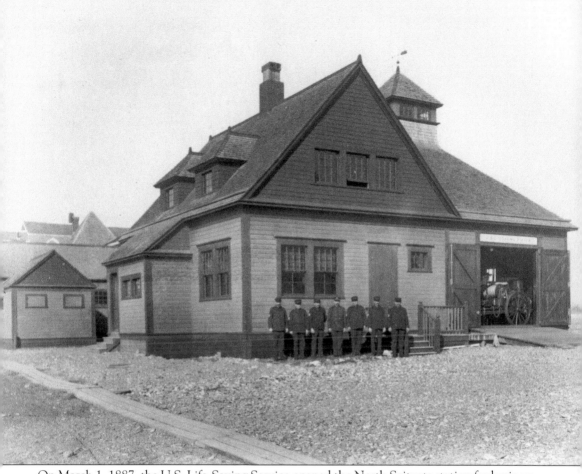

On March 1, 1887, the U.S. Life-Saving Service opened the North Scituate station for business on Minot Beach, a Bibb No. 2–type station, named for architect Albert B. Bibb. Due to the possible intrusion of breaking waves during northeast storms, the service built the structure to stand perpendicular to the shore, its boat room nearest the water. Originally, the crew numbered six surfmen and keeper George H. Brown. The station would remain open between September and April. In 1895, the service extended the work year to run between August and May. Brown, who originally worked at the Fourth Cliff station, captained the North Scituate station past the turn of the century. In December 1905, he gave way to the younger Fred Franzen, a storm-tested Cape Cod surfman who had once been involved in a gun battle with another lifesaver on the beach. The Life-Saving Service also built Bibb No. 2 types in Hull and Plymouth, the former of which is today the Hull Lifesaving Museum. Both the North Scituate and the Gurnet stations are now private homes.

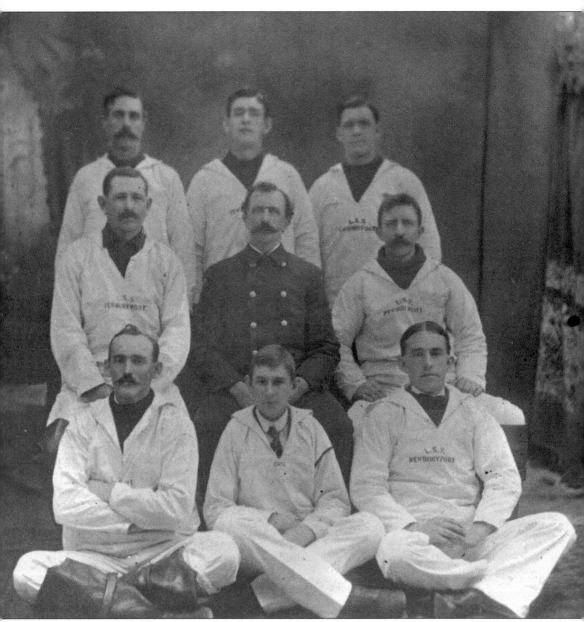

Born in Scituate on August 8, 1859, Thomas John Maddock (middle row, center) followed the path taken by many young Irish boys of Scituate: finding work on the dories that left the beaches each summer day in search of Irish moss. The boat-handling skills he learned as a mosser trained him well for a career in lifesaving. When the U.S. Life-Saving Service came to build the North Scituate station in 1886, Maddock signed on as a carpenter; when the station opened in March 1887, he became a lifesaver. About ten years later, he accepted a transfer to the Merrimack River station in Newburyport, where he served as keeper for 22 years. According to a 1909 article in *Along the Coast* magazine, Maddock by that time had sent in 142 wreck reports in which 506 people were involved. He landed 110 of them, saving at least 45 from sure death. He poses here with his Plum Island crew. Maddock died on July 4, 1945, and is buried in West Concord, New Hampshire.

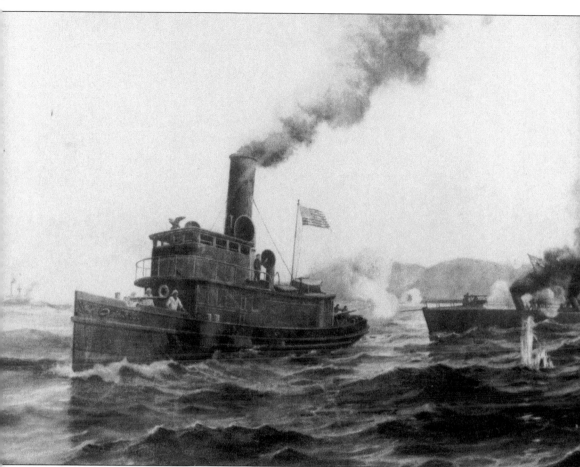

Although Capt. Frank H. Newcomb was not born in Scituate, the news of his heroics aboard the U.S. Revenue Cutter Service tug *Hudson* during the Spanish-American War gave the folks in that town reason to celebrate. Born the son of Captain Hiram Newcomb, who was born in Scituate, Frank joined the U.S. Navy during the Civil War, serving without distinction for two years. He then made the U.S. Revenue Cutter Service his career, even serving as the assistant inspector of life-saving stations for the Second Life-Saving District (the coast of Massachusetts) from 1894 to 1897, a frequent and well-known visitor to the Fourth Cliff and North Scituate stations. On May 11, 1898, he and his crew aided the disabled U.S. Revenue Cutter Service vessel *Winslow* at the battle of Cardenas Bay, Cuba, advancing to fasten lines under a galling fire, and pulling her to safety. For his heroic action he received the Congressional Gold Life-Saving Medal, the highest lifesaving honor given out by the American government.

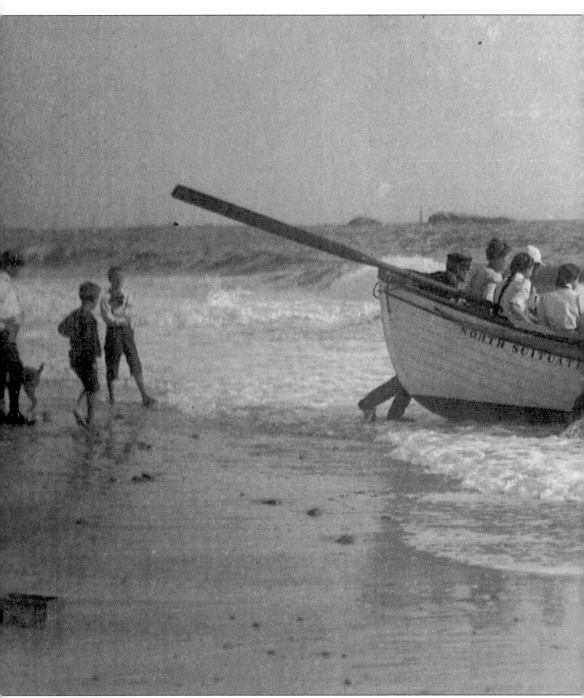

The surfmen of the U.S. Life-Saving Service drilled five days each week. On Mondays and Thursdays, they practiced firing their Lyle gun, the line-throwing cannon that enabled them to perform breeches buoy rescues, setting the lines and hauling a "victim" down from a practice pole. Every Tuesday, they launched a lifeboat, rolled it over, and righted it, a process that had to be completed in 30 seconds. On Wednesdays, they rehearsed using signal flags to warn ships at sea of surrounding bars or shoals. On Fridays, they brushed up on their artificial resuscitation

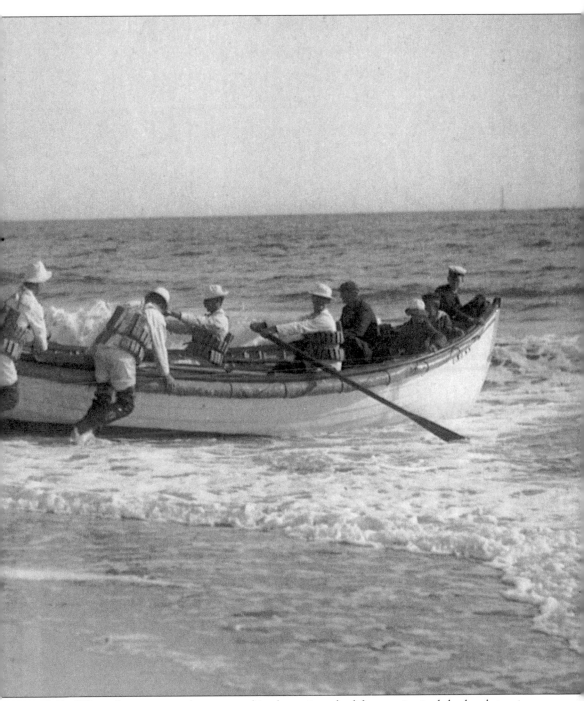

skills. When the warm weather returned in the spring, the lifesavers invited the locals to view, and sometimes participate in their daily drills. The surfmen happily gave up their seats in the breeches buoy to substitute "shipwreck victims," and some lucky young men and women—as shown above—even got to take a ride in a lifeboat. Many station keepers, such as George Brown at port-side stern, tried to make their crews a visible part of the community.

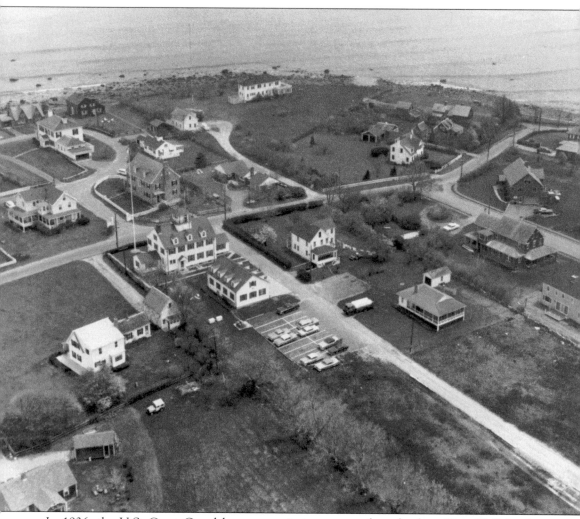

In 1936, the U.S. Coast Guard began negotiations to purchase land on First Cliff for the construction of a new station. In 1937, Enos Stoddard and J.H. MacDonald sold some of their land, although MacDonald retained a parcel between the main and equipment buildings and the boathouse, claiming that he planned to build a number of resort homes. Completed on Sunset Road in 1938, the colonial revival–style building replaced the North Scituate station on Surfside Road. The building changed very little during its first four decades, but on February 21, 1984, fire gutted its interior, heavily damaging the watchtower, which the Coast Guard never rebuilt, deeming it "no longer operational." They did, however, build planned pavilions on either side of the station, completing the current facade.

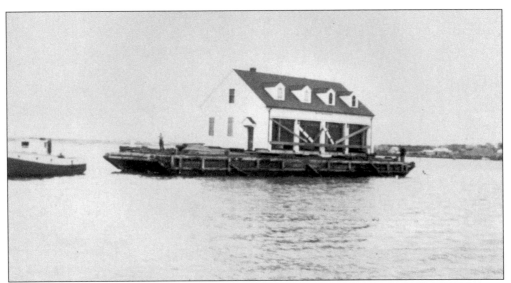

With the addition of work trucks to the equipment lists of the stations came the need for new outbuildings. The four-bayed equipment building that now rests comfortably behind the First Cliff station chose a rather harrowing mode of transport to its new home. Although the U.S. Life-Saving Service had lost entire stations on barges in the past, this building survived.

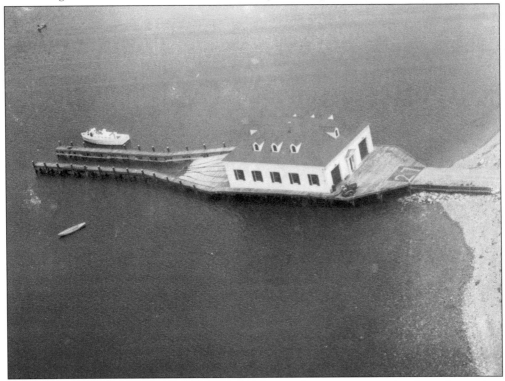

Even the station's boathouse, accessed by a 20-foot-wide easement running from the station, showed signs of the colonial revival architectural style. Between the finger piers, marine railways led to three separate bays for maintenance and repair. Off the pier rests a 38-foot cabin picket boat.

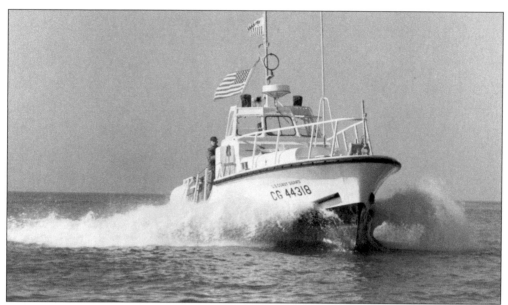

Between 1963 and 1972, the U.S. Coast Guard constructed 105 Motor Lifeboats (MLBs) that were 44 feet long. One of the earliest units built, the 44318, spent more than three decades searching for and rescuing distressed mariners off the coast of Scituate. With the advent of the technologically superior 47-foot MLB, the U.S. Coast Guard began selling off the 44-foot vessels. Today, the 44318 patrols the coast off Uruguay.

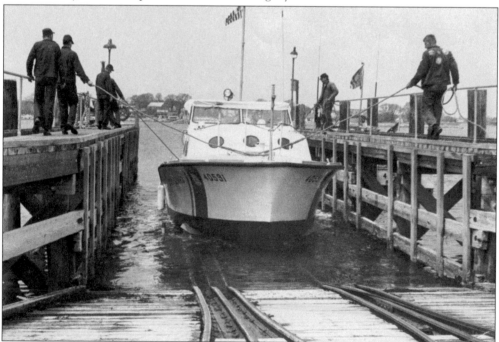

Today's omnipresent 41-foot Utility Boat (UTB) replaced a 40-foot craft, constructed between 1950 and 1966 for search and rescue and port security services. The 40-foot UTBs had replaced 38-foot picket boats and other non-standard craft built before and during World War II. Here, crewmen haul the 40591 onto the marine railway at the Station Scituate boathouse.

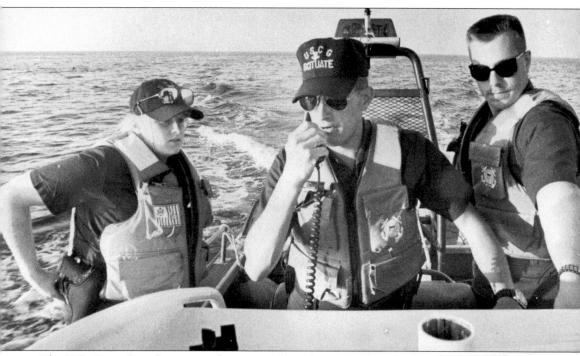

The U.S. Coast Guard's presence has come full circle since 1879. The Fourth Cliff Life-Saving Station's original crew numbered seven men, one keeper, and six surfmen. At its height, the station on First Cliff housed 35 personnel. After a service-wide reorganization in 1997, the U.S. Coast Guard designated Scituate as a station-small, under the jurisdiction of Hull's Station-Point Allerton. The National Oceanographic and Atmospheric Administration now inhabits the station on First Cliff as the U.S. Coast Guard will construct a new, smaller building on Cole Parkway. The station will be home to seven personnel, one supervisor and two three-person boat crews. When completed, the station will assure the continuation of the long-standing tradition of the U.S. Coast Guard's vigilant protection of the Scituate shoreline.

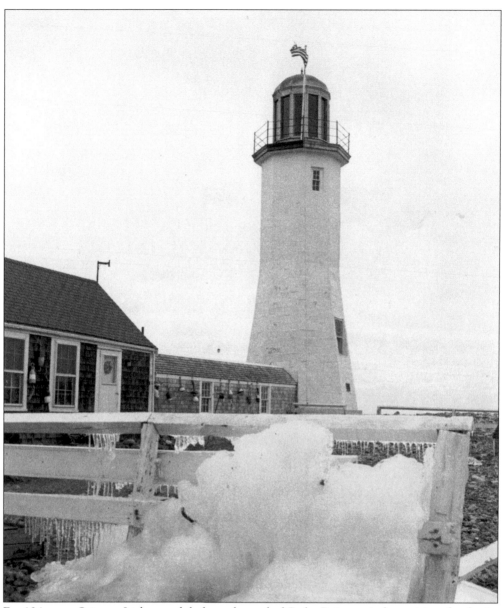

For 134 years, Scituate Light stood dark on the end of Cedar Point, quietly awaiting the day its light might shine again. A small beacon on the end of a breakwater that was constructed off the point functionally replaced the old tower in 1891, but it could never fill the void in the hearts of the townspeople who saw it as the symbol of their town. In 1916, Congress passed a law that enabled the town to purchase the lighthouse from the federal government for $1,000. Expecting to raise the funds at the next town meeting, selectman Jamie Turner could not believe his ears when his wife, Jessie, explained to him that she had seen a public auction notice in the newspaper announcing the intended sale of the light. He hurried his way to the town treasurer, who signed over a check for $1,000, which Mrs. Turner rushed to Boston to purchase the light. In 1968, the Scituate Historical Society assumed administrative custodianship of the lighthouse and the keeper's cottage, refurbishing, maintaining, and (in 1994) relighting it as a private aid to navigation.

Four

STORMS, SHIPWRECKS, AND DISASTERS

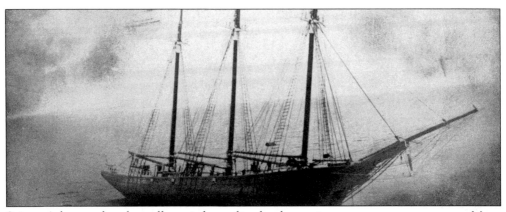

Scituate's long and geologically varied coastline has been witness to many severe storms. Many residents recall the Blizzard of 1978, but there have been numerous other ferocious storms as well. Topping the list would be: the Minot's Light Gale of 1851 that destroyed the first lighthouse of that name and claimed the lives of two of her keepers; the *Portland* Gale of 1898 that changed the course of the North River; the Christmas storm of 1909; and the *Etrusco* Blizzard of March 1956.

Some shipwrecks resulted in a tragic loss of life, while others provided a bonanza for residents in washed-up cargo. The loss of the *Forest Queen* at Third Cliff in 1853 and the grounding of the lumber schooner *Kenwood* in 1926 are perfect examples. The *Forest Queen* was carrying a valuable load, including 12 tons of silver. Her salvaged silver supposedly helped one resident finance the construction of a new home on First Cliff. Lumber from the *Kenwood* was sold off the ship at bargain prices. Several cottages on Cedar Point and barns in the West End were built entirely from her lumber.

Above, the 619-ton lumber schooner *Helena* came ashore on Fourth Cliff on January 30, 1909 with 500,000 board feet of yellow pine. The Fourth Cliff U.S. Life-Saving Station crew saved all eight men aboard.

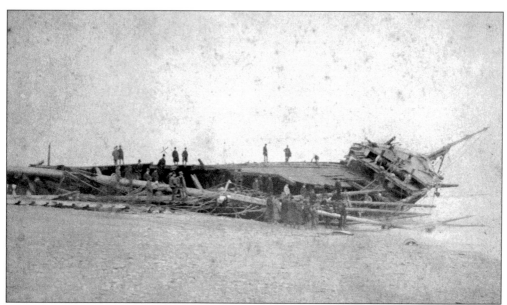

The brig *T. Remick* was driven ashore at North Scituate in a violent winter storm on March 5, 1889. Her crew was saved by the surfmen of the North Scituate U.S. Life-Saving Service Station, but her cargo of sugar, molasses, and cocoa was a total loss. Only a small amount of mahogany was saved.

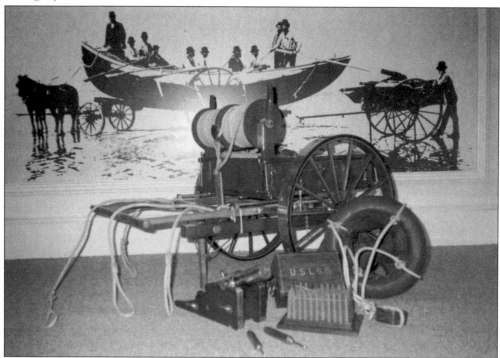

This exact scale model of a U.S. Life-Saving Service beach cart is made from mahogany salvaged from the *T. Remick*. It was presented to keeper George H. Brown of the North Scituate station by Lyle gun manufacturer Henry C. Dimond. It is the only one of its kind in the country today and is on exhibit at Scituate's Maritime and Irish Mossing Museum.

Minots Ledge Lighthouse. Cohasset, Mass.

destroyed in gale of April, 1851

Wednesday night April 16
The light house won't stand over to night — she shakes 2 feet each way now —

J.W. & J.A.

This scrap of paper enclosed in a sealed bottle was picked up in Massachusetts Bay by a Gloucester fisherman the morning after the storm which destroyed the Lighthouse.
The initials "J.W." and "J.A." are those of the two Keepers who perished at the time.
Joseph Wilson
and
Joseph Antoine.
Presented by
Mrs. Percy S. Rogers.

On April 16, 1851, a storm of unprecedented fury struck the Massachusetts coast. The tide height produced by the storm was not exceeded until the blizzard of February 1978. The head lightkeeper had gone to Boston on official business the day before, leaving his two young assistants, Joseph Wilson and Joseph Antoine, in charge. When he returned to Cohasset the day of the storm, high seas prevented him from reaching the light. All that evening, the light shone brightly, but just before midnight, those on shore heard the light's bell ringing wildly above the noise of the storm; they then saw no light nor heard any more from the bell. Moments later, the lighthouse collapsed into the raging sea. This note, written by one of the light keepers, details the final moments before the lighthouse toppled into the raging waters. It was found a few days later by a Gloucester fisherman in Massachusetts Bay.

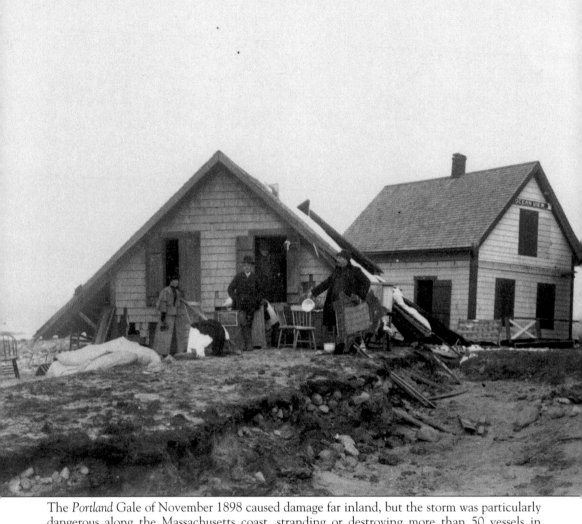

The *Portland* Gale of November 1898 caused damage far inland, but the storm was particularly dangerous along the Massachusetts coast, stranding or destroying more than 50 vessels in Boston Harbor and about that many off Provincetown. In all, more than 350 ships met with some degree of damage between New Jersey and Nova Scotia, and more than 500 people lost their lives, including 192, by latest estimates, aboard the steamer *Portland* alone, which went down without witnesses. During the storm, volunteer and government lifesavers rescued more than 130 people. The storm changed the course of the North River, as it gave the river the power to disintegrate a barrier beach in one night, separating the Humarock section from the rest of the town forever. As with all natural disasters, the 1898 gale destroyed some buildings and left others intact. This family is salvaging what little they can, while the house next door escaped almost unscathed.

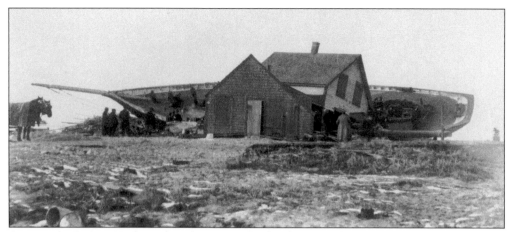

Because the Boston Harbor pilot schooner *Columbia* displayed the number two on her mainsail, she was considered a lucky vessel. Her luck ran out at the height of the *Portland* Gale. Somewhere off Minot's Light, her anchor chains parted and she was driven ashore at the southern end of Sandhills Beach. None of her crew of five survived. The loss of the *Columbia* stunned the maritime community along the Boston waterfront.

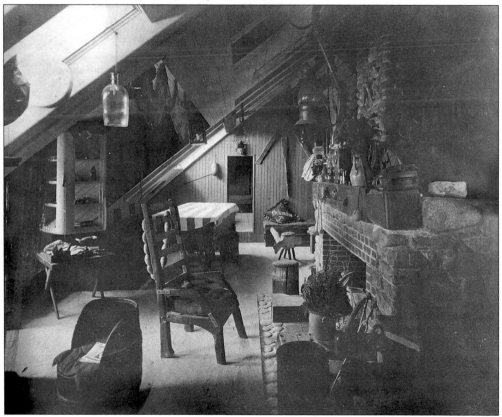

Otis Barker purchased the wrecked *Columbia* and turned it into a small maritime museum. He constructed a large fireplace inside the hull and had an observation deck above it. People from near and far visited this unique ship on the beach. *Columbia* remained at Sandhills until the early 1930s.

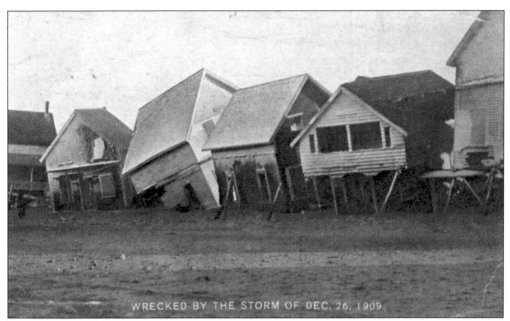

WRECKED BY THE STORM OF DEC. 26, 1909.

A severe gale and snowstorm struck Scituate the day after Christmas in 1909. The storm caused widespread damage along the coast and produced near record high tides. One victim of the gale was the three-masted schooner *Nantasket*.

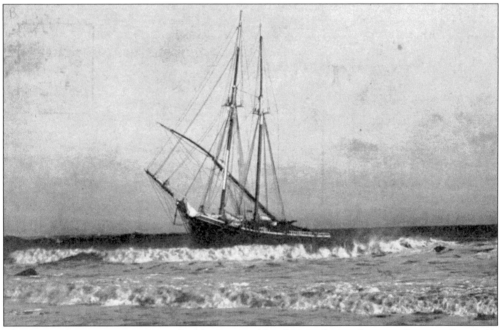

The *Nantasket* was carrying a valuable cargo of lumber and was driven ashore at Sandhills Beach at the height of the storm. The Massachusetts Humane Society volunteers quickly rigged the breeches buoy and had already brought some of the crew in when the North Scituate Life-Saving Service crew arrived. The *Nantasket* was a total loss. However, a part of the ship still exists. The "Jug in the Chimney House" on Lighthouse Road contains some timbers from the schooner.

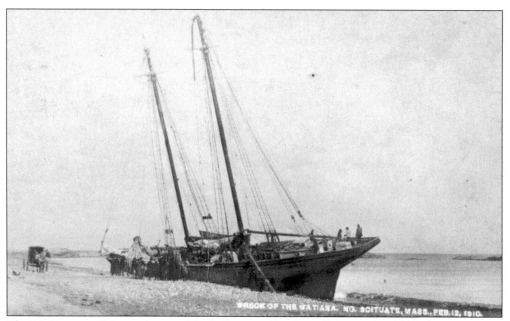

The *Matiana* was driven ashore at North Scituate Beach on February 12, 1910, during a severe snowstorm. Capt. Frederick C. Franzen, keeper George H. Brown's successor, led the surfmen of the North Scituate station in the successful rescue of all 17 men aboard the vessel.

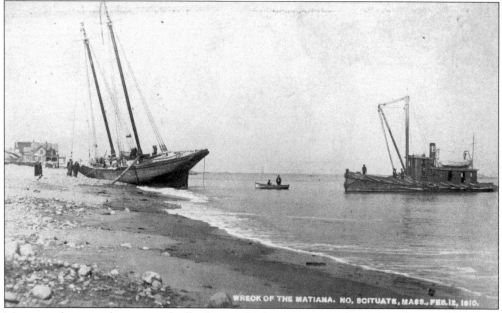

Most wooden vessels were so badly damaged when coming ashore that they could not be salvaged, but the *Matiana* was an exception. Sand was dug out from around her, and a tug succeeded in pulling her off the beach at high tide. A similar although more complex operation was used to pull the *Etrusco* off the beach in 1956.

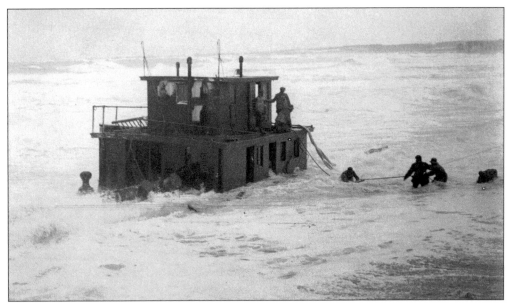

One of the most dramatic scenes at North Scituate took place on March 4, 1916. The storm that took place that day put the crew of the barge *Ashland* in serious peril, as its deckhouse broke off and began floating to shore. The surfmen from the North Scituate Coast Guard Station were able to save almost the entire crew, but two sailors had drowned before the lifesavers could reach them.

The captain and the surviving crew of the *Ashland* were taken into the North Scituate Coast Guard Station to recuperate after their ordeal. Here, in one of the few known photographs of the building's interior, they rest and warm themselves in front of the stove.

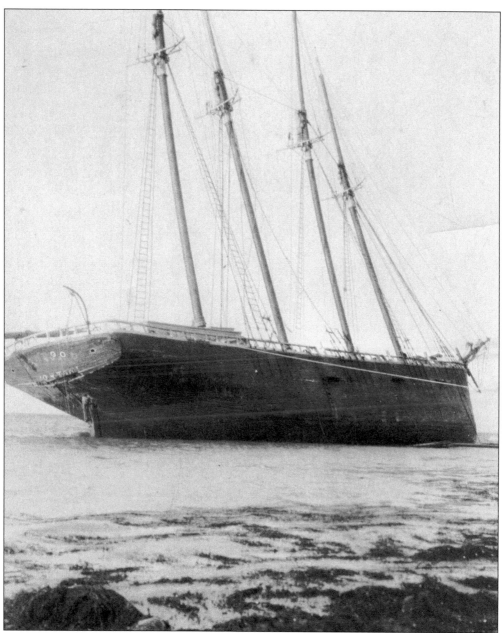

The four-masted schooner *Kenwood* was driven ashore at Cedar Point during a blinding blizzard on February 4, 1926. She had left Nova Scotia a few days before with a huge cargo of more than 500,000 board feet of lumber. A local resident spotted a burning tar barrel from the ship and notified the U.S. Coast Guard. Roads were clogged with snow, making rescue efforts difficult. Coast Guardsmen commandeered the Massachusetts Humane Society surfboat on Jericho Road and launched the boat into high seas. All of the *Kenwood*'s crew was rescued and taken to a local cottage, where they were soon sitting by a warm fire. When the firewood was gone, the furniture was burned. Several cottages were built from the *Kenwood*'s lumber and for many years one cottage bore the name of the vessel. The schooner was burned on July 4th of that year. What a great bonfire it made!

Boston Post

THE GREAT
Breakfast Table Pap
OF NEW ENGLAN

SATURDAY, JUNE 14 1930 **

Established 1831

TWENTY PAGES—TWO CEN

LEFT TO DIE UNAIDED IN SEA OF FIR

No Lifeboats Lowered From Fairfax, Shi
Quartermaster Testifies---Mad Panic, Terribl
Struggle in Flaming Water

Scituate's most tragic maritime accident was not the result of a storm, but rather of the greatest enemy of all mariners: fog. On June 10, 1930, the small passenger liner *Fairfax* headed south out of Boston Harbor. At the same time, the gasoline tanker *Pinthis* was exiting the east entrance of the Cape Cod Canal. A couple of hours later, both vessels were off the North River, desperately trying to locate buoy No. 4 in the fog. At 8:00 that evening, the *Fairfax* rammed the *Pinthis*. Immediately the tanker erupted into a flaming inferno. All aboard the *Pinthis* were killed, while many of the passengers and crew of the *Fairfax*, thinking she was about to sink, leaped overboard. On June 11, 1930, the *Boston Evening Globe's* headline read, "47 Dead, Tanker Sunk in Collision off Scituate." The *Boston Post's* headline is above. The final death toll was 50 lives lost. Controversy raged as to which vessel was at fault, and a federal investigation was held. Although the captain of the *Fairfax* was initially charged with negligence, he was eventually acquitted.

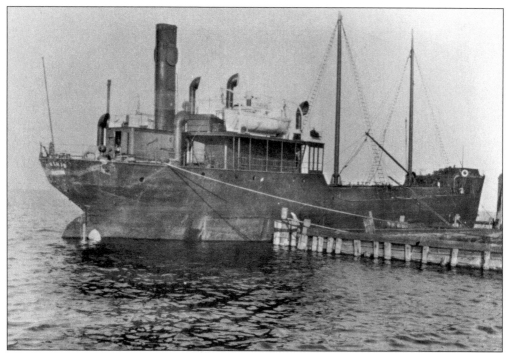

The *Pinthis* was a 216-foot tanker under the command of Capt. Albert Jones. The tanker was carrying one-half million gallons of high-octane gasoline. The gasoline leaked from the *Pinthis'* watery grave for a week, creating a hellish glow through the persistent fog. (Courtesy of the Mariners Museum).

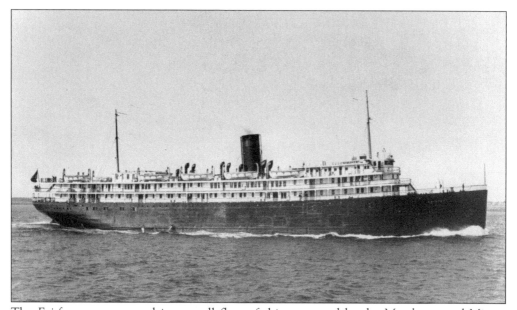

The *Fairfax* was one vessel in a small fleet of ships operated by the Merchants and Miners Transportation Company of Baltimore, Maryland. This was the first run of the season for the ship, so only 70 passengers were aboard. (Courtesy of the Mariners Museum.)

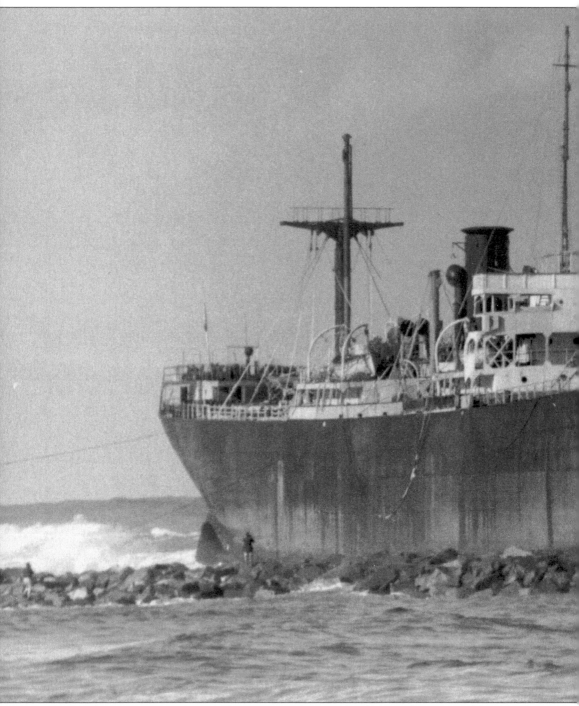

The 441-foot *Etrusco* was driven ashore on March 16, 1956, during a late winter blizzard. The same howling, 80-mile-per-hour winds that sealed her fate also made it impossible to rescue her crew until early the following day. The stranded ship attracted tourists from across the Northeast. Some weekends, more than 50,000 people flocked to Cedar Point to take in the peculiar site of a ship sitting upright high on the beach. *Etrusco*'s owners gave up any hope of

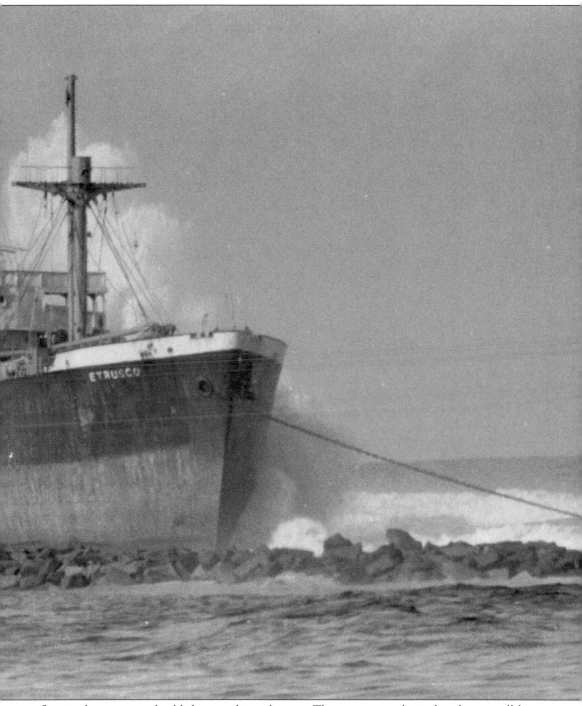

floating her again and sold the vessel to salvagers. The new group devised a plan to pull her back to sea and began work in early September. On Thanksgiving 1956, with only a few diehard *Etrusco* watchers present, the ship was finally freed from the rocky shore. The ship was then repaired, and renamed the *Scituate*. The Scituate Maritime Museum holds permanent exhibits on the *Columbia, Fairfax-Pinthis,* and *Etrusco* stories.

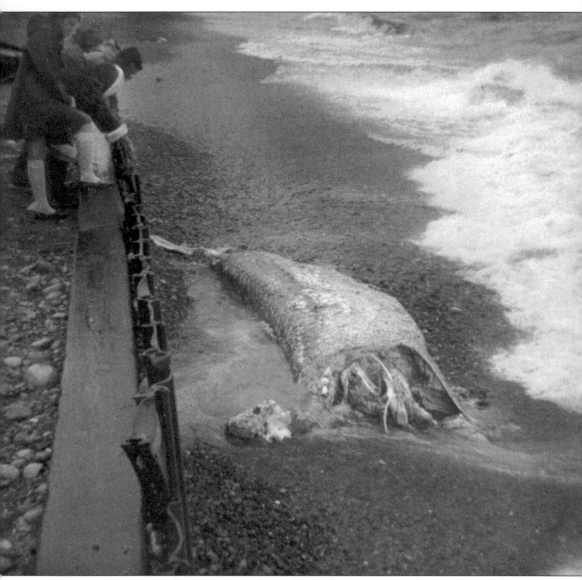

You just never know what you are going to find when you walk the beaches of Scituate. Beachcombers expect to find shells, starfish, crab and lobster claws on Scituate's sands, but no one could have predicted what came ashore on Sunday, November 16, 1970. Early that morning, *something* was spotted floating in the water off the beach near Fourth Avenue. The current continued to carry it northward throughout the day until high tide, when it was deposited on Mann Hill Beach. As news of the "Scituate Sea Monster" spread, thousands of folks rushed to the shore. While experts disagreed as to its identification (a shark? a whale? a new, unknown denizen of the deep?), they did agree that it should be removed from the sand in which it was buried and transported to the New England Aquarium in Boston, where it could be studied and possibly identified. But as the sands washed over the form, it began to deteriorate rapidly. Burying it on the beach, the experts agreed that it could never be properly classified, calling it either a basking shark or an unclassified sea serpent. Maritime historian Edward Rowe Snow laid out seven-to-one odds in favor of it being some sort of sea serpent. What do you think?

Five

SCHOOLS

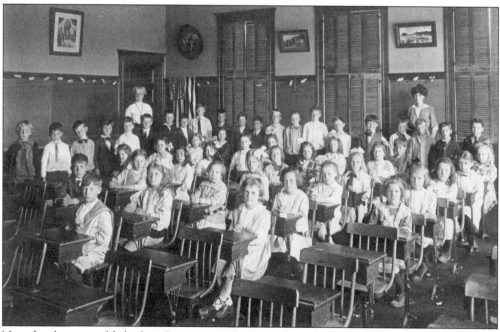

No school was established in Scituate until 1700, when the townsfolk requested that James Torrey, who lived in Greenbush, be allowed to keep a grammar school as the 1677 law allowed. He settled on a wage of 20 shillings per student, 15 shillings paid by parents and 5 shillings from the town. During the 1700s, this school would become a "moving" entity while the town meeting frequently discussed where the school would best serve the town. For 40 years, the school would be at one end of the town for one-third of the year, at the other end of the town for another third, and in the middle for the rest of the year. In 1789, Massachusetts allowed towns to form school districts. Scituate adopted this plan, which remained in place for almost 100 years. School houses were built in various districts, and were sometimes moved by ox and wagon when the population shifted. After South Scituate became a separate town in 1849, redistricting was needed, and ten school districts were established.

REGULATIONS.

1. The School-houses shall be opened for the admission of the scholars at quarter before nine o'clock, at which time the teacher shall be expected to be present.

2. Scholars must not use the school-room for a play-room, throw stones, speak or write any profane or unchaste words, or go beyond the school-yard limits at recess.

3. Scholars should not leave school before the end of the term, if it can be avoided, and should always be present at Examination.

4. Scholars who injure any school property shall pay the damage.

5. Teachers are not to suspend their schools without permission from the Superintendent or District Committee, or make up lost time on Saturday.

6. Teachers may take one half day in each term to visit other schools, and a day to attend the meeting of the Plymouth County Teachers' Association.

7. Schools may be suspended on Fast Day, June Day, Fourth of July, Thanksgiving, and Christmas.

By Order of the Board,

ALEXANDER J. SESSIONS, Superintendent.

GEORGE WHITNEY MERRITT, Secretary.

SCITUATE, March, 1868.

SCHOOL YEAR OF THIRTY-EIGHT WEEKS.

SPRING TERM,	. . .	March 23d to June 26th.
FALL TERM,	. . .	August 24th to November 13th.
WINTER TERM,	. . .	November 30th to February 19th.

Extract from a Law of the Commonwealth.

" Whoever willfully and maliciously, or wantonly and without cause, destroys, defaces, mars, or injures any school-house; or any of the out-buildings, fences, walls, or appurtenances of such school-house; or any furniture, apparatus, or other property, belonging to, or connected with, such school-house; shall be punished by fine not exceeding five hundred dollars, or by imprisonment in the jail not exceeding one year."—[GENERAL STATUTES, Chap. 161, Sec. 67.]

TODD, PRINTER, 11 CORNHILL, BOSTON.

From the very beginning, Scituate's teachers and students had to know how to behave.

Older students from the three district schools first met on the lower floor of the Union School in 1828. Twenty-one years later, a second floor was added. The Union School (its 1898 attendees shown here) was located in what is now the parking lot at the intersection of First Parish and Stockbridge Roads.

The Brook Street, or Central Harbor School was the largest in Scituate with 98 students. In a very early photograph, Gertrude Gardner and her 1877 charges pose outside of the building, the construction date of which has yet to be definitely determined. We do know, however, that the building today serves as the senior center at 27 Brook Street.

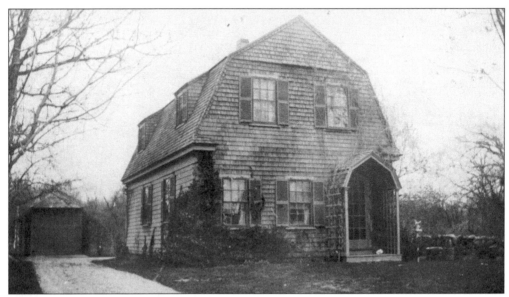

Egypt Primary School was erected near the end of April 1848. That year, 41 students were in attendance. It was closed when students transferred to the Hatherly School. This picture shows the structure being used as a private home. The Packard family made extensive changes to it in 1960.

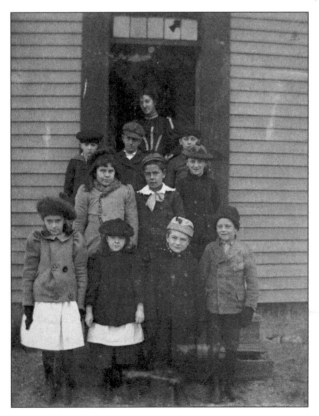

The school was located on Captain Peirce Road and was also known as the Charles Street School. The teacher pictured is Sadie Pratt Litchfield, the wife of Stephen Litchfield and the daughter of Elijah Pratt and Mary Rodriguez.

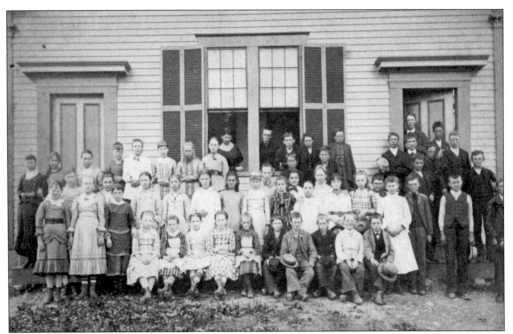

West Grammar School was located on land near the junction of Captain Peirce Road and Country Way. It opened in September 1873 and was designed for 50 students. To be admitted to the two new grammar schools, pupils had to pass an examination in reading, spelling, geography, and arithmetic.

Edith Holland and Hatty Damon pose in this 1896 picture with their West Grammar School students. In 1872, two grammar schools were decided upon by the town—one in the eastern side of the town and one in the western. During the early 1890s, concerns arose over the overcrowded conditions at the school.

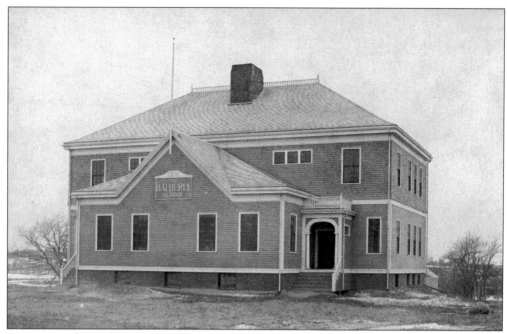

A great step forward was made with the building of Hatherly School on Country Way in 1896. This school would be in use until 1959, when it was closed and demolished. Today, it is the location of the Purple Dinosaur playground.

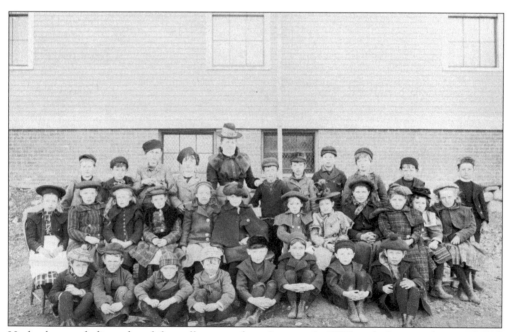

Hatherly was dedicated and formally opened on January 1, 1897 with four teachers and 118 pupils. There were four classrooms with two grades being taught in each. The students had been housed at six district schools. The cost to build Hatherly was $8,600.

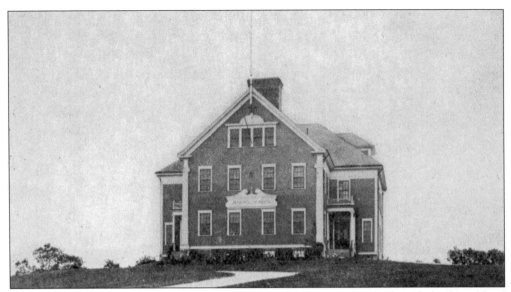

Jenkins School was dedicated and opened in September 1902. It was built with funds and land generously donated by Emeline Jenkins. A staff of four teachers taught 176 scholars that year. These students had previously attended five district schools. The cost to build Jenkins was $16,000.

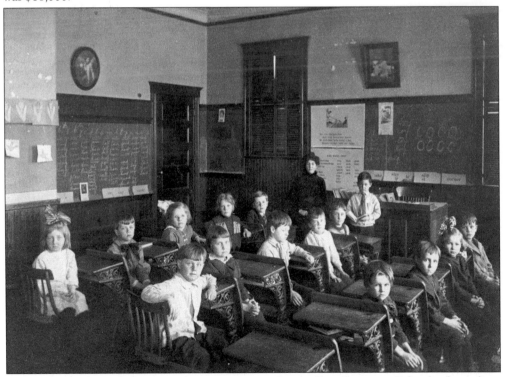

Jenkins had to be built because of severe overcrowding at East Grammar School, where there were nearly 90 students in one room. In 1916, the year after Gertrude Gillis's pupils stopped learning long enough to have their picture taken, the Jenkins School furnace had to be replaced at a cost of $55.

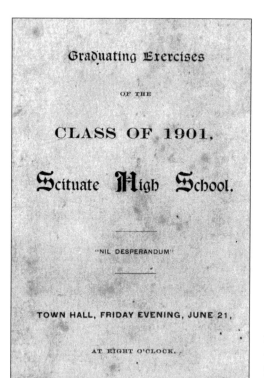

Graduating Exercises

OF THE

CLASS OF 1901,

Scituate High School.

"NIL DESPERANDUM"

TOWN HALL, FRIDAY EVENING, JUNE 21,

AT EIGHT O'CLOCK.

In small classes at the turn of the century, no one was excused from oral presentations. And who wanted to be, anyway? If we listen closely out at Scituate Center, we can almost hear the echoes of the graduating exercises for the Scituate High School Class of 1901.

. . Class of 1901 . .

Edith May Burbank
Frank Merton Colman
Albert Lorenzo Dalby
Jesse Thomas Ellms
Joseph Patrick Flynn
Grace Emma Harwood
Aurilla Gertrude Litchfield
Mary Frances McDonald
Edwin Walter Newdick
Alonzo Austin Pratt, Jr.
Margaret Bradford Spear
Edythe Almira Turner

✢✢

MUSIC
THE HELEN TRICKEY STRING QUARTET
HELEN TRICKEY, First Violin.
ERNEST ASTLE, Second Violin.
MABEL MAKECHNIE, Viola.
JOHN LITTLE, 'Cello.
HARRY L. HEARTZ, Pianist.

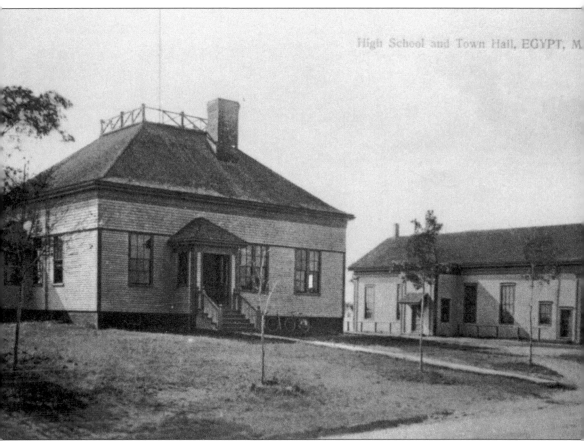

According to Jarvis Freymann's *Scituate's Educational Heritage*, "Scituate's first town-wide public high school classes were conducted in the Old Town Hall (at right, above) from 1854–1857 and from 1860–1893. Demolished in 1959, the original building stood on the present site of the west wing of Gates Intermediate School on First Parish Road. The town's first purpose-built high school (at left) opened in 1893 and served the town until the new high school building (now the central section of Gates Intermediate School) was completed in 1916. Moved to its present site on Cudworth Road in 1919, the Little Red School House has, since 1984, served as the headquarters of the Scituate Historical Society." In 1930, two wings and a cupola were added to the new high school. The ninth grade in the grammar school was eliminated, and the concept of a junior high school was accepted. It was later housed in the west wing of the high school.

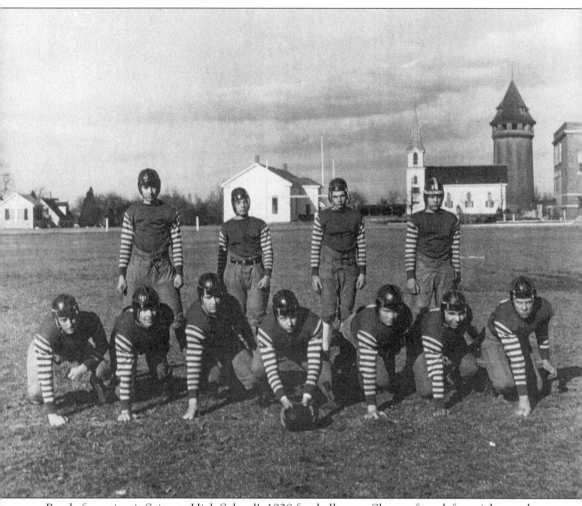

Ready for action is Scituate High School's 1928 football team. Shown, from left to right are the following: (front row) Merlin Cole, Earl Nicholes, Tom Lawson, Bud Dwight, Arnold Lawson, Peter Mackey, and Sam Tilden; (back row) John Stewart, Jerry Delay, Art Chase, and Mal Wilder. There were 24 students in the graduating class of 1928. The class motto was "Finished—Yet Beginning." The class colors were blue and gold, and the class flower was the forget-me-not. In 1901, superintendent Edgar Willard wrote, "Scituate is surely rapidly growing. This growth will soon be felt in the schools." Twenty-seven years later, superintendent Harold C. Wingate reported on that prediction: "The three school buildings in Scituate are all overcrowded The present school plant is inadequate in every way. Hatherly and Jenkins schools rank so low on a school building card that any money spent in changing them would be wasted." Some things never change.

Six

CHURCHES AND PUBLIC BUILDINGS

In 1623, "Merchant Adventurer" Timothy Hatherly arrived at the new Plymouth settlement on the ship *Ann*. Exploring up the coast, he was impressed with the land around the North River. According to *Old Scituate*, "Successful fisheries and a lucrative trade with the natives and with the Dutch were anticipated, and these necessitated a safe and convenient place to build the vessels to carry on these industries. The section around 'Satuit' was adaptable for these purposes." When the Puritan "Men of Kent" came to Scituate at the beckon of Hatherly sometime before 1628, they carried their religion with them. Escaping persecution in England, they built the first incarnation of the First Parish Church of Scituate, a meetinghouse of logs on a hill overlooking the ocean, thatched with grass from the nearby marshes, on Meeting House Lane. When this church burned, Timothy Hatherly presented to the church "a parsonage and lands" at Scituate Center. At least five versions of the First Parish Church were built there at intervals, culminating in the erection of the "Old Sloop" in 1774. This structure was a "double decker," with wide galleries on three sides, two rows of large windows, and a portico at the east end. This steeple could be seen a long way at sea and was used as a landmark by mariners. Inside were 68 pews on the floor and 12 in the galleries, seating 400 people. From the earliest times, Scituate folk celebrated their religion in high style.

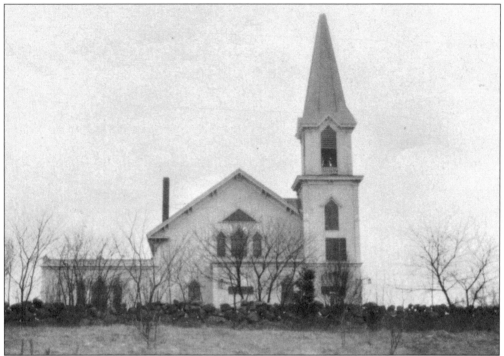

The "Old Sloop" burned on July 4, 1879, reportedly through the carelessness of boys with firecrackers. Smoke first appeared around noon coming from the porch, but the fire had too much of a head start on anyone hoping to battle the flames. The present church was erected and dedicated on May 18, 1881.

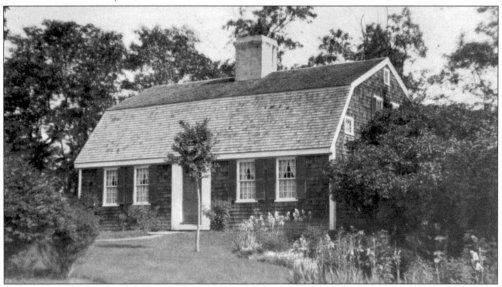

While the new Unitarian church was being built, use of the Cudworth House across the street was graciously offered for meetings of the church's flock, in the same house where the Baptist Society of Scituate met from 1821–1825. The Unitarians met upstairs and used the current loom room for midday lunch and refreshment. The Scituate Historical Society today maintains the Cudworth House as a historic site, opening it to the public each summer.

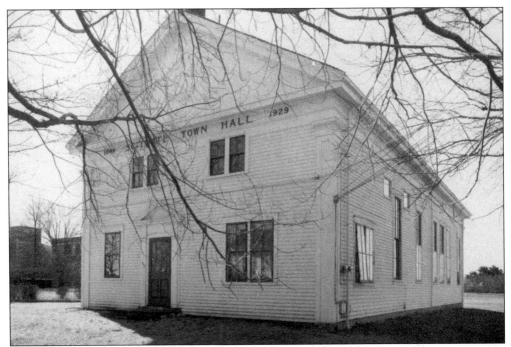

Nearby, on the same side of First Parish Road as the Cudworth House, was the town hall, constructed in 1849. This is where town meetings were held and municipal business transacted. It was even used for high school basketball games and other sports activities. Margaret Cole Bonney, in *My Scituate*, remembered attending community sing-alongs there during World War I, crooning tunes like "It's a Long Way to Tipperary" and "Oh, How I Hate to Get Up in the Morning."

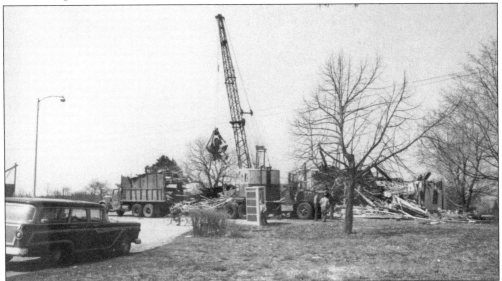

As early as 1925, a movement had begun for the construction of a new town hall. The town meeting voted to indefinitely postpone its discussion until the 1950s, also voting along the way not to make repairs to the old structure. In 1959, the old building finally came down to make way for new administrative offices at the intersection of First Parish Road and Route 3A.

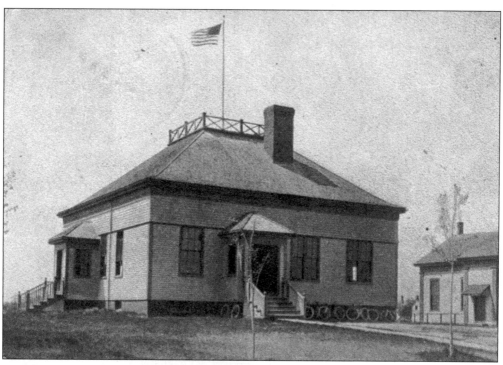

In order to get to the town's new high school on a spring or fall morning at the turn of the century, Scituate's "up-to-date" scholars mounted "boneshakers" and their "glorious contraptions" and pedaled as hard as they could. With their bicycles, yesterday's high school students seemed to take up less parking space than their counterparts do today.

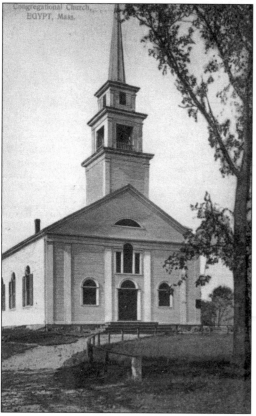

In 1825, some members of Rev. Nehemiah Thomas's flock separated from the Unitarian Church to form their own church on Country Way, calling it the First Trinitarian Congregational Church. Many churches at this time had similar controversies, and the courts ruled that records, plates, and property should remain with the first churches, but the "seceders were welcome to retain the doctrines if they wished." The church has hosted the Scituate Historical Society's dinner meetings for many years.

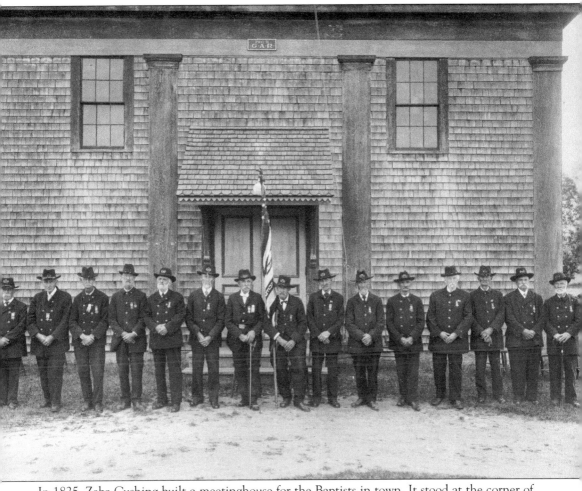

In 1825, Zeba Cushing built a meetinghouse for the Baptists in town. It stood at the corner of Main and Central Streets, which were changed in 1917 to Country Way and First Parish Road, respectively. The Baptists used the structure until selling it to Joshua Jenkins for $600 in 1869. The Jenkins family rented the building to different interested parties for functions, including a group of Civil War veterans who purchased it in 1883 upon Jenkins's death to make it the home of the George Whitmarsh Perry Post No. 31, Grand Army of the Republic. The G.A.R. opened the building to other organizations as well, including the Charles E. Bates Camp of the Sons of Union Veterans, and the Ladies Auxiliary to the Sons of Veterans. It remained the G.A.R. Hall until 1934, when the post's last member, Milton G. Litchfield, died. Scituate's last Civil War veteran, Francis Litchfield, died in 1937. The G.A.R. Associates sold the building to the town, which sold it to a new group called the G.A.R. Hall Associates, composed of the Kiwanis, 60-Plus Club and the Sea Scouts. The building returned to the town in 1995 and was sold the Scituate Historical Society the following year. As the oldest public building in Scituate, the society has grand plans for the old hall.

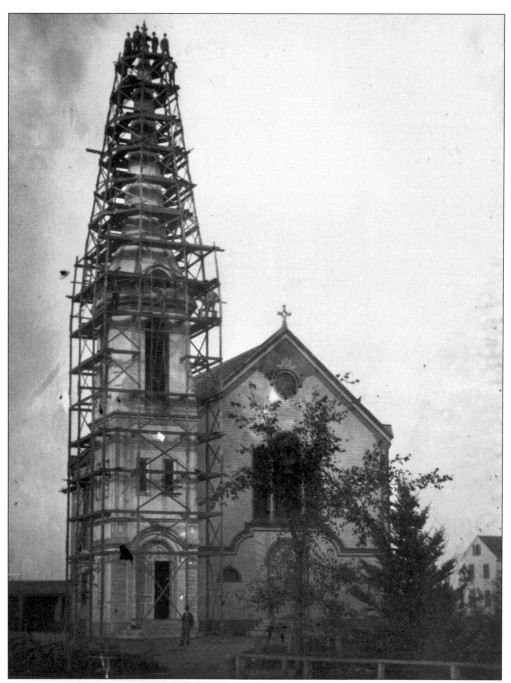

The Baptists moved closer to North Scituate with their new and larger building in 1869. This photograph made from a glass negative shows the steeple being constructed, probably *c.* 1870. Notice that there was to be a clock face in the steeple. The church soon had a great resurgence of membership; by 1890, more than 100 children were enrolled in the morning Sunday school. The church held Thursday evening prayer meetings as well. These sessions were well attended, and it was permissible, and without censure, for a young man who was courting to walk his girl home.

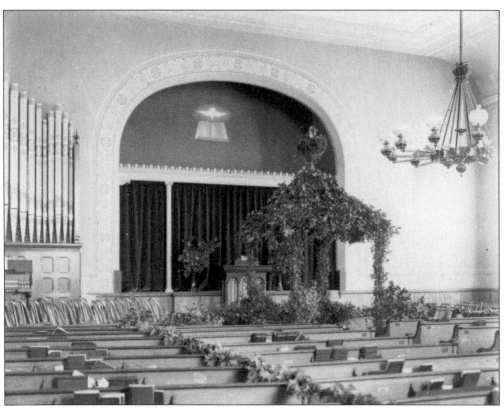

The inside of the church was fitted out "most handsomely" with a kerosene lamp chandelier. In this photograph, it is wonderfully decorated for the wedding of "Aunt" Sally Bailey and Moses Lowe Brown on October 21, 1902. The ubiquitous Henry Turner Bailey painted the dove above the baptistery.

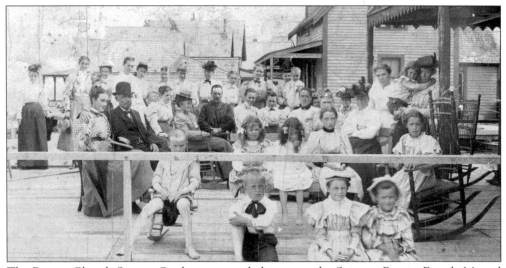

The Baptist Church Sewing Circle—previously known as the Scituate Baptist Female Mutual Religious Improvement Association—also enjoyed fun times. Here, some of the members enjoy a picnic with their families at North Scituate Beach in 1898.

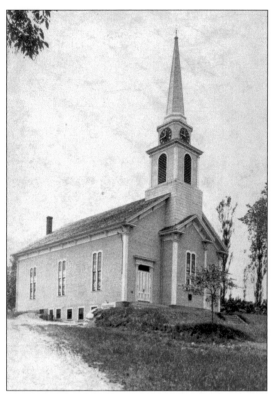

The Methodists in Scituate built their first church in 1826 on Brook Street, but it burned down on July 4, 1865. The incident was described in the *History of Methodist Episcopal Church* as "an accident, of course, but a costly bonfire to patriotism." Nonplused, the church's trustees moved to build a new edifice, which they did in 1868. On the early morning of Sunday, January 13, 1918, the Harbor Methodist Church also burned to the ground, a conflagration "supposed to be of incendiary origin."

Before the month was out, the trustees met and voted to rebuild the church immediately. During the planning and building phases, the trustees also arranged for the use of Allen Hall in the Allen Library for services. Its cornerstone was dedicated on June 27, 1920. The church regularly hosts the Scituate Historical Society's dinner meetings.

Just like the "Men of Kent" before them, Daniel Ward and his family brought their religion with them when they came to Scituate in 1854. They were the first Catholics in town. However, it was not until 1872 that this church structure—St. Mary's of the Nativity on Meeting House Lane—was begun. The first mass was celebrated in the basement on December 25, 1872.

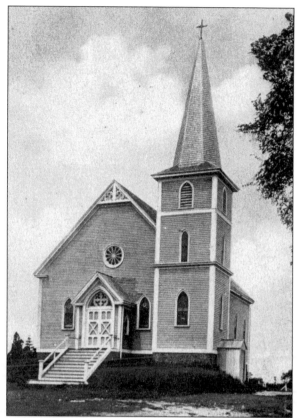

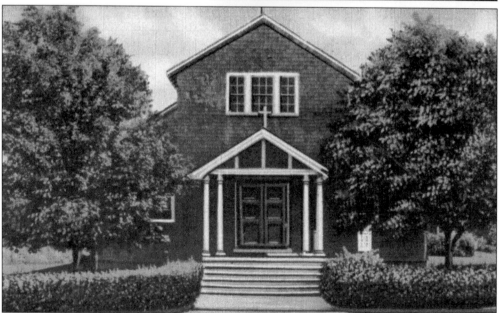

When that wooden church burned, the present church was erected at the corner of First Parish Road and Kent Street. In the spring of 1903, a summer chapel, St. Mary's of the Visitation, was built at Sandhills, and the first mass there was celebrated on July 5 that year.

With fire being such a hazard, small fire stations were erected in strategic spots around town. Shown is the company of Hose No. 3 in North Scituate Village ready for the call. From left to right are the following: Ernest R. Seaverns (driver), Frank Cook, Joseph Morris, Pearl Vickery,

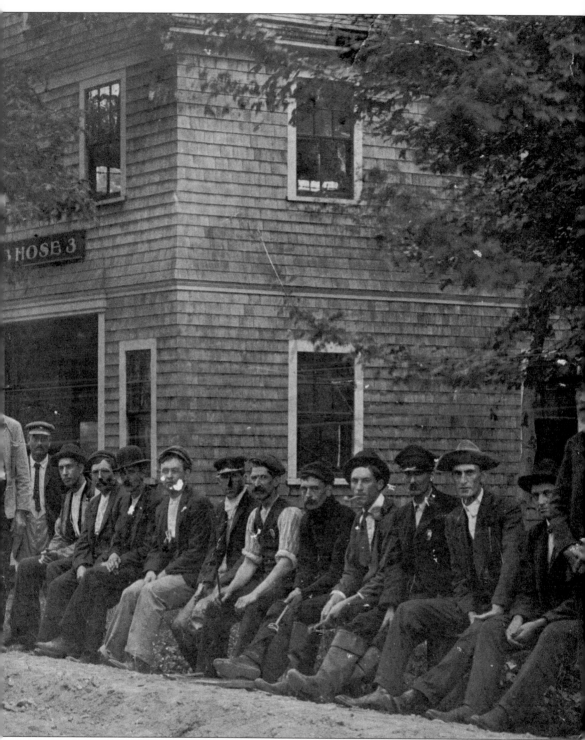

James Dalby, Charles Vickery, Francis Hyland, Archie Torrey, Irving Whiting, Edward Bush, Elmer Ramsdell, Fred Hyland, Charles Pierce, unidentified, unidentified, and Alfred Seaverns, the chief of the Scituate Fire Department.

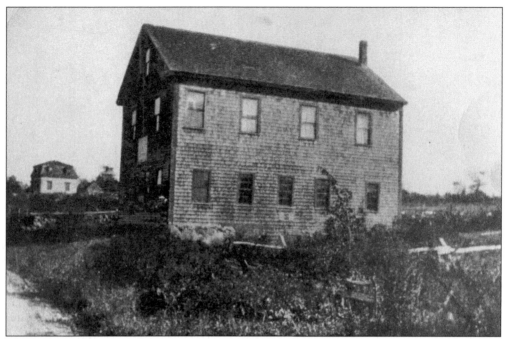

The old Conihasset Hall at the end of Blossom Street (now Booth Hill Road) at the intersection with Clapp Road, was the scene of many happy times. Dances, parties, games and generally good times were enjoyed by the people there. Some of the more straight-laced townfolk frowned upon these "excesses," but most had a fabulous time.

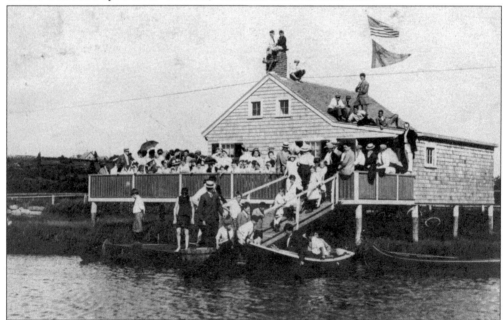

Just off Gannett Street, where the brook goes into the gulf, stood the Konihasset Boat Club House. The club's members performed plays, dramatic interpretations, and musicals. Boating seemed to be incidental. It was here, on the dirt road in front, that Rev. Bartlett of the First Baptist Church lost his life in an accident.

There were many civic organizations whose aim it was to improve the environment and overall quality of the town. The aptly named Town Improvement Association was one and the Mount Hope Improvement Association Society was another. These organizations were joined by P.Y.O.C. (Paddle Your Own Canoe) and the Odd Ladies. There are still a few people in town who remember dances being held at the Odd Ladies Hall, which is today a private residence on Country Way.

Directly across the street from the Odd Ladies Hall was the Peirce Memorial Library, given in memory of his wife by Silas Peirce and his family. The library boasted a beautiful fireplace in the center, with a raised platform at one end for lectures and entertainment. Previous to this arrangement, the North Scituate Library Association had been meeting in a room above Seaverns Store, using it as a lending library with dues of 25¢ per year. Each member was expected to contribute books, used or new, for the "edification of the patrons."

Seven

THOMAS W. LAWSON'S
DREAMWOLD

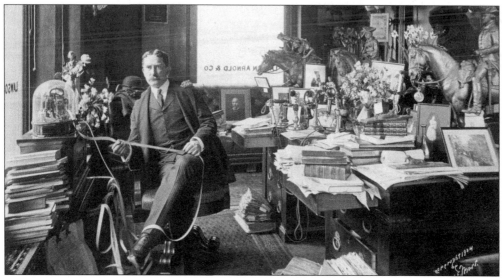

When reporter Alfred Henry Lewis stepped into Thomas William Lawson's office, he admitted that "the first thought was one of confusion—a jumble, a scene of floral and artistic mob violence." But after allowing himself a few moments of visual absorption, he realized, "Every picture, every flower, every created thing of art or nature sort, was where it might have a best expression. There were sequence, congruity, harmony, propriety; every beauty had been given truest emphasis."

Lawson, a millionaire by age 30, and at the height of his success worth approximately $60 million, came to the Egypt section of Scituate with the dawn of the 20th century and built an estate the likes of which the South Shore had never seen. Through his love for horses, dogs, flowers, and boats, he proved to the world the truth behind writer Maurice Baldwin's words: "Aladdin's lamp would be a poor substitute for Mr. Thomas W. Lawson's check-book."

"Dreamwold," wrote E.C. Lincoln in the *National Sportsman* in 1902, "an enchanted fairyland, the creation of a man's genius, pluck, and indomitable persistence. He took a piece of bleakest New England, a barren and sterile territory, covered with stones and rocks He took a tremendous tract of this unhappy land and literally made it over to his purpose. This he transformed into a paradise." Nearly 1,000 workmen—guided by architect E. MacMulkin, landscape engineers, gardeners, and, ultimately, the "Copper King" himself—laid underground electric cable, installed telephones, flattened out macadamized roads. They built houses, kennels, and stables—all of which faced south for the breeze. They changed a "Stony New England hillside so thick with briers that a rabbit could scarcely get through" into a farm that became a village unto itself, with each structure "a compliment and artistic offset to its neighbor, and the whole blended into a complete and perfect picture that brings rapture to the soul of the artist." To assure that the buildings at Dreamwold would represent his motto of "Beauty, Strength and Speed," Lawson ordered the workmen to remember that "everything must be heavy, strong, simple and quiet; if four by six will do, make it six by eight."

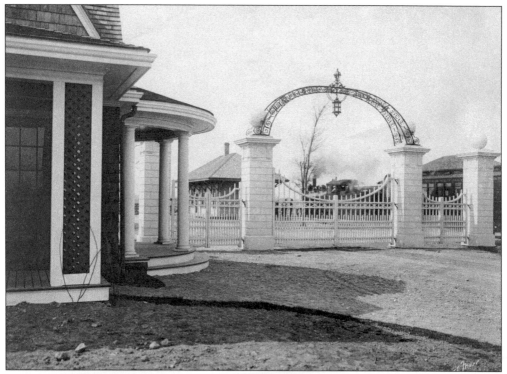

These handsome gates graced Dreamwold's main entrance, located near the Egypt Railroad Station, as evidenced by the train chugging through the background. A similar set now known as Lawson's Gates still stands on Branch Street. Visitors touring the grounds checked in at the office building on the left for their passes, with a request to avoid pathways marked "Private."

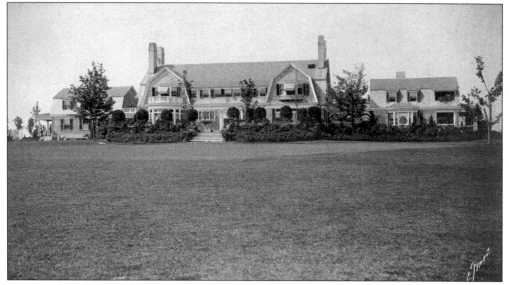

Dreamwold Hall faced the sea, and from its verandah Lawson could see Minot's Light. The hall served Lawson, his wife Jeannie, and their children as their main home. "Not a castle, stern and forbidding, not a great stone pile, standing sentinel challenging your approach, but a house, and such a house, pleasant, inviting and homelike, speaking comfort and happiness in every respect."

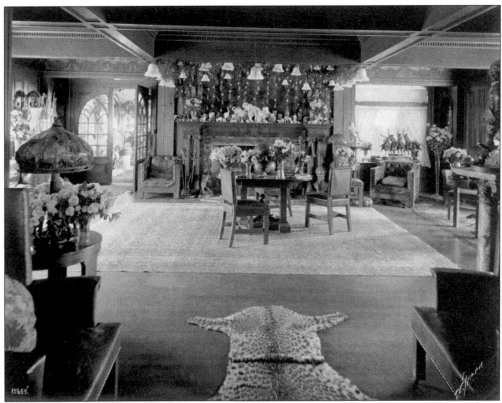

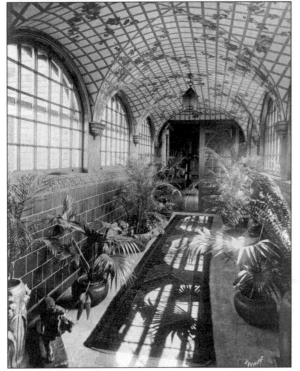

The interior of Dreamwold Hall assaulted the eyes in much the same fashion Lawson's office did—with carefully arranged visual mayhem. In the living room, Lawson showed his weakness for pachyderms, and his belief that elephants brought good luck, by lining the mantel with representations in bronze, ivory, gold, silver, and wood. Around the rest of the room, oak and leather abounded beneath a frieze depicting the rest of Lawson's favorite animals, among them bulls, horses, and dogs. A few of his furnishings are displayed at Scituate Federal Savings Bank in Scituate Harbor.

Leading from the living room to the billiards room, the conservatory housed numerous potted palms of different varieties, alternating with bronze statuettes of more of Lawson's animal menagerie. Lawson had the curved ceiling of tiles painted in oils.

Off the billiards room, and also a part of the bachelors' wing (with the library), a small colonial-style hallway led to the upstairs chamber. Polished mahogany forms the banister, while a Persian rug partially covers the floor, watched over by Presidents Washington and Roosevelt.

The dining room, perhaps the most simply decorated room of them all, held some of Lawson's most striking pieces. A pumpkin-shaped and tinted Tiffany lamp hang above the table with corresponding pumpkin blossom lights accenting it throughout the room. The fireplace andirons, designed by Lawson himself, define the victory and defeat of stock speculation: one bear gets the honey, while the other gets stung.

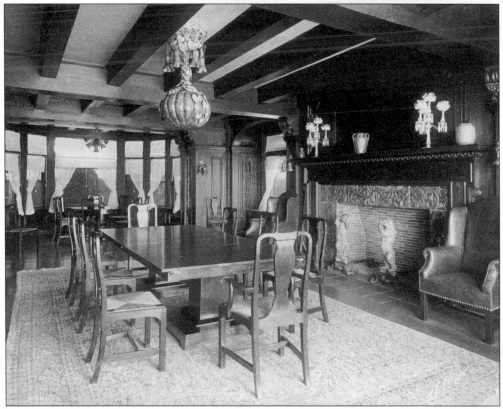

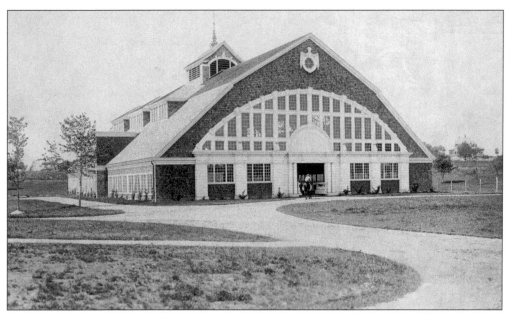

In 1906, the town's valuation listed Lawson as owning 169 horses, 46 yearlings, 52 cows with 16 of their young, 6 bulls, 20 sheep, and 635 fowl. At his riding academy building, the world's best horses were trained. "No horse show is complete without an exhibit of some of the Lawson blooded stock, and other exhibitors from all over the country have to look to their laurels when he is in the field, and many of them have to see their favorites accept second place to his beautiful animals." This building was later removed to the Brockton Fairgrounds, where it burned down in 1933.

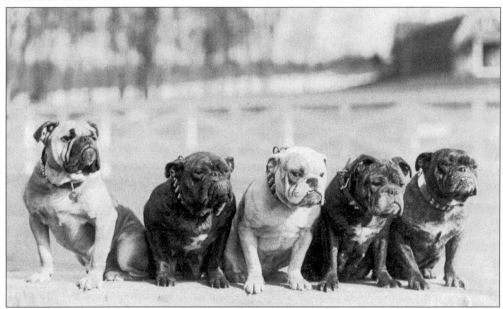

Approximately 150 dogs romped in the kennels of Dreamwold, but their master loved no breed better than his internationally famous English Bulls. In his own words, "Take him all in all, he is the 'gent' of Dogdom." From left to right are Champion Fashion, Champion La Roche, Rodney Monarch, Champion Thackeray Soda, and Champion Glen Monarch.

While each of the buildings on the grounds of Dreamwold showed similarities to its neighbors—gambrel roofs, gray walls, green blinds, and white trim—Lawson designed each to perform its own particular function and to look slightly different from all the rest. He saw to it that each one connected to the next through its electric, phone, water, and sewer lines. Above stands the blacksmith shop.

With horses of all sizes pulling carriages or running free on the grounds and tracks, blacksmithing was more than a full-time job on the Lawson Estate. The shop had room for the simultaneous shoeing of eight horses.

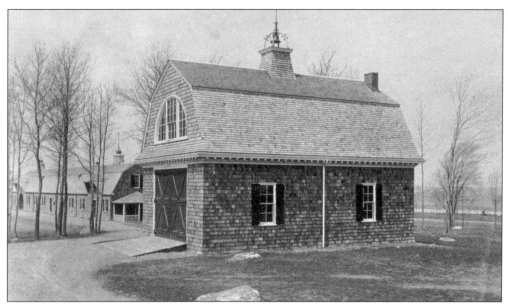

In case of emergency, Lawson had a system of fire alarms built into the buildings on his property that alerted the crew waiting at his own personal fire station if a blaze started. Inside could be found a chemical engine, hose wagon, and ladder truck.

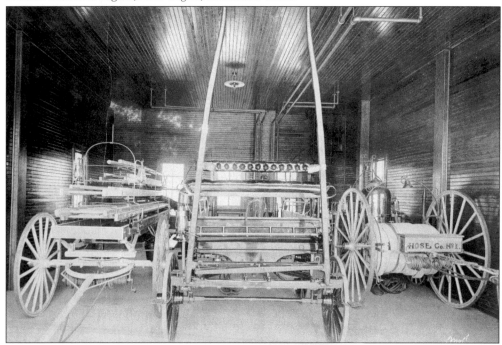

The department earned its keep the day before the wedding of Lawson's daughter, Gladys. Passing the Main Street Grocery at Egypt, Gladys and her fiance, Eben Blaine Stanwood, noticed smoke coming from within the little store. Stanwood charged into the building to make sure no soul was trapped inside as a bucket brigade formed behind him. Gladys hurried back to Dreamwold and summoned the firefighters, who joined the North Scituate crew on the scene, saving the surrounding buildings from flying embers.

Lawson's Dutch-style windmill revolved freely at the top to allow its four 60-foot-long arms to best take advantage of the breezes. The harnessed wind power ground grain and cut ensilage, coarse feed for horses and cattle.

Even passing pigeons could find comfort at Dreamwold. The pigeon cote could provide shelter for humans as well, but they had to stay within a walkway, caged from the birds, who even had a separate breeding area. To enjoy sunlight and grass without fear of molestation by predators, members of the winged tribe could spend time in the wire net enclosed yard, a consistent 10 feet out from the building.

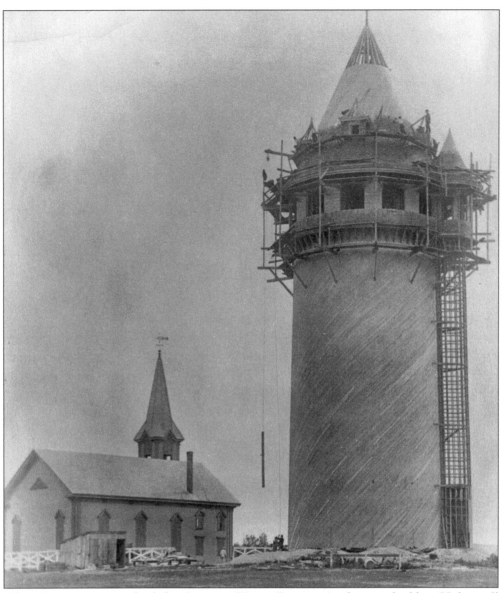

When Lawson got word of the Scituate Water Company's plans to build a 75-foot-tall standpipe across the way from his new estate, he immediately asked for their permission to finance and have constructed a facade that would be more pleasing to the eye than a conical tower. His hand-picked architect returned from Europe with sketches of numerous towers, but one, a 15th-century Rhine River structure, caught Lawson's fancy. Construction began in 1901, and just before its completion a year later, a workman plunged 100 feet off the staging around the tower to his death.

At 153 feet tall, Lawson Tower, as it is now called, completely overshadowed the spire of the Unitarian church beneath it. Lawson also installed a 10-bell chime accessed by climbing 123 stairs, which wound upward in a separate turret. Eleven open ports in the bell room allowed for the Westminster chimes to be rung out twice daily in all directions. Satisfied with the result, the "Copper King" turned the tower over to the water company. In 1974, the American Waterworks Association designated Lawson Tower as an American Water Landmark.

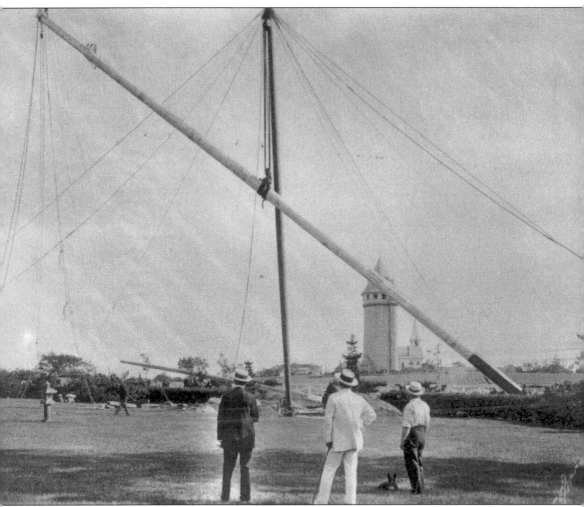

Years later, Lawson realized that his estate needed a flagpole; of course, being the man that he was, it had to be the most impressive flagpole ever seen. To find it, he looked clear across the country to Oregon, where lumberjacks cut down a 318-foot-tall pine, the tallest tree ever to leave that state. It was carried by train across the continent, but upon its arrival in Boston railroad executives realized that no car in New England could carry the 12-ton pole down the coast to Lawson's Egypt farm. Splitting it into two sections, teamsters hauled it over the road by drays. On the way over the Fore River Bridge between North Weymouth and Hingham, one of the wheels of the dray carrying the 112-foot section broke through the planks, scaring the teamsters into believing that their time had come. The rest of the bridge held, however, and two hours later they were again on their way.

Set in 18 feet of solid concrete, the flagpole reached 172 feet into the sky, regularly flying a 20 by 30-foot national ensign. On Sundays and minor holidays, Dreamwold's employees threw a 40 by 60-foot flag to the breeze; on Memorial and Independence Days they hauled out the biggest, a flag measuring 50 by 75 feet. During World War I, Lawson raised a special flag beneath the ensign, with 16 stars representing the men from his estate that had entered the service of their country.

An avid sportsman, Lawson built a 140-foot yacht, the *Independence*, to race against Sir Thomas Lipton's challenger for the America's Cup race, but the New York Yacht Club disallowed the boat's inclusion in the contest due to a technical flaw in its design. Enraged, Lawson ordered the boat broken up for firewood, the mast becoming the flagpole on Planter's Hill at World's End Reservation in Hingham. However, he would still enjoy cruising in his personal yacht, *Dreamer*.

Lawson's love of elephants spilled outside of the doors of Dreamwold Hall and onto the lush, natural pathways that he and his family enjoyed on warm spring and summer mornings. He donated the elephant fountain to the local Grand Army of the Republic post in 1920 as a centerpiece for their Memorial Common, the land for which he had also donated. When Lawson died a few years later, the G.A.R. donated the park to the town and renamed it Lawson Common.

Miles of rambling roses creeped and crawled their way all over Dreamwold, turning already inspirational settings into visions of pure romance. Apparently Lawson had a lapse in his otherwise overflowing creativity when he decided upon a name for this structure. It was simply known as Cottage No. 8.

As if his 200-plus acres were not enough, Lawson culled out a corner to place a sanctuary for him and his wife to escape to when feeling overburdened, calling it the Love Nest. His reclusion at times should not have been surprising. Once, when approached by neighbors begging forgiveness for not calling on him within his first few months in town, he responded by saying, "That's quite all right. Think nothing of it. If we'd wanted society we'd have gone to the North Shore."

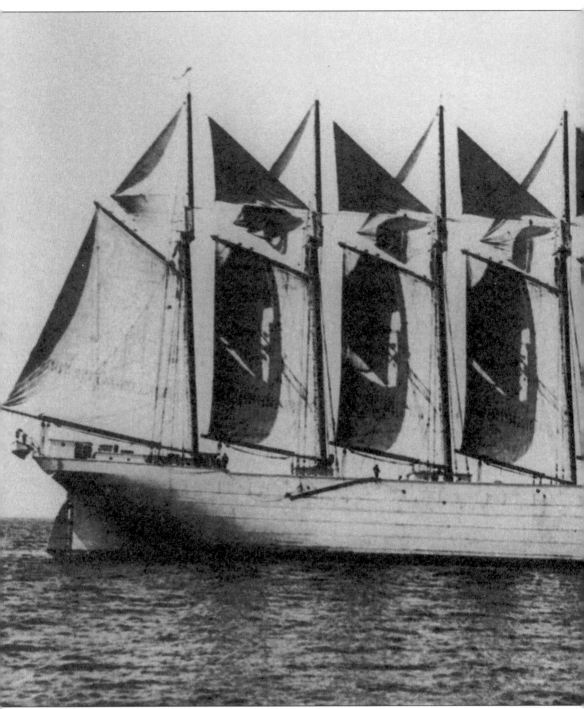

Going against the advice of his lucky pocket watch, which rang six bells when he asked it how many masts his new schooner should have, Lawson sank money into the world's first seven-masted steel-hulled schooner, the *Thomas W. Lawson*. At 403 feet in length, the *Lawson* carried 43,000 square feet of sail and 6 steam engines, arranged for loading and discharging cargo as well as for propulsion. Capt. Arthur L. Crowley dropped command of the six-masted *George W*.

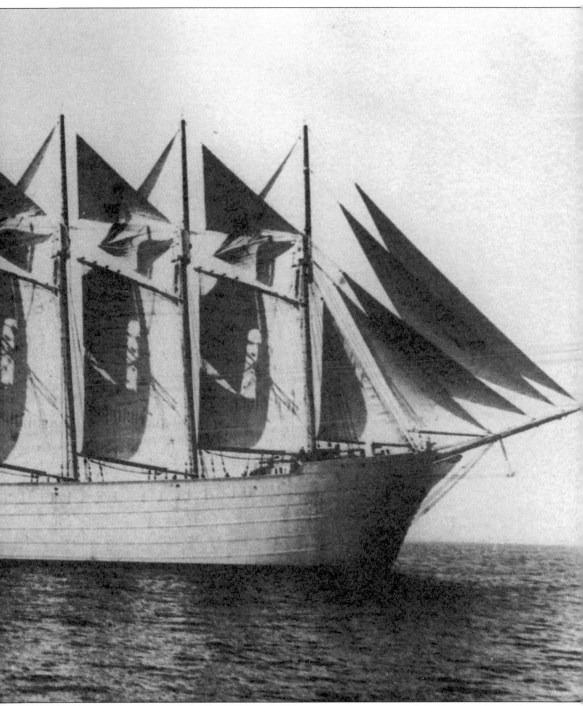

Wells to take the helm of the larger vessel, starting it on its coastal coal runs along the Northeast. On November 27, 1907, Captain George W. Dow took her on her only transatlantic voyage. Sixteen days later, on Friday the 13th of December, she wrecked on Hell Weather Reef in the Scilly Isles off the coast of Cornwall, England, killing all but two of her crew.

During his long and at times tempestuous career, Thomas Lawson found ways to alienate much of the financial world, especially through his insider's look at the machinations that took place on Wall Street, namely *Frenzied Finance*, published in 1905. Journalist Charles Edward Russell wondered just how much of Lawson's grandstanding "was business acumen, how much megalomania, how much love of the spotlight, how much resentment against his business associates, and how much a sincere desire to expose and correct great evils." No matter what his purpose, the end result of his failed financial ventures culminated in the selling off of his dream estate before his eyes to pay $225,000 of debt. Ironically, or perhaps poetically, Lawson died nearly penniless on February 8, 1925. For a quarter of a century, he somehow affected the lives of everyone in Scituate, leaving behind a collection of landmarks that still hold people in amazement 75 years later.

Eight

LANDMARKS AND LEGENDS

Certain scenes and stories of Scituate history will linger in our minds forever, making us smile unexpectedly, tucked into our homes on the coldest of New England winter nights, or chuckle softly, as we walk by familiar places in the warmth of a South Shore summer. Who will ever forget Percy Mann's resistance to progress or Thomas Lawson's free spending days? Other tales will remind us of the rough roads our forebearers traveled as we pass the sites where ships were wrecked and lives were lost.

Some of Scituate's favorite stories defy classification—how, for example, Daniel Webster's yacht *Lapwing*, above, ended up rotting away on Scituate's shore. These stories stray well beyond the bounds of local history to become important parts of state and even national lore. Other events that happened in Scituate may not be well remembered as having been tremendously important at the time, but instead give us teaching tools, signposts in our country's history, that can be used to help understand our nation as a whole.

On the final leg of our journey through Scituate's past, we will visit a potpourri of landmarks, some extant and some now gone, and we will do so in no particular order. When all is said and done, whether we live in North Scituate, Greenbush, the West End or Humarock, we are all a part of the greater whole—the beautiful town of Scituate.

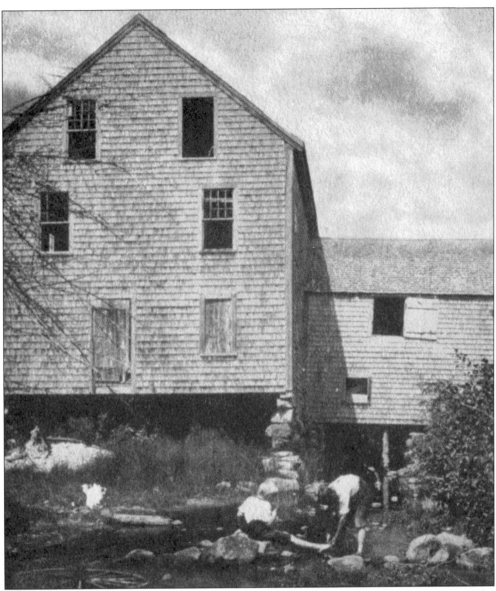

Isaac Stedman arrived in the New World aboard the *Elizabeth* in 1635, making his way up to the settlement at Greene Bush from Plymouth a few years later. In 1640, he dammed First Herring Brook and built the Old Colony's first water-driven gristmill. Ten years later, he sold the mill to George Russell of Hingham. After six years, Russell joined into a partnership with John Stockbridge, who stayed for less than a year before moving to Boston. In 1665, John's son Charles bought out Russell. On May 20, 1676, the valiant men of Scituate made their stand against King Philip's marauding army, eventually repulsing their attack and saving the mill from destruction.

For the next 154 years, the Stockbridge family ran the mill, after which it was sold to the Clapp family, who operated it until the beginning of the 20th century. In 1922, the Clapps donated the site to the Scituate Historical Society. For the past 78 years, the society has opened the mill as a historic site. Today, the machinery is inoperable, but steps are being taken to see that the mill will grind corn again in the near future.

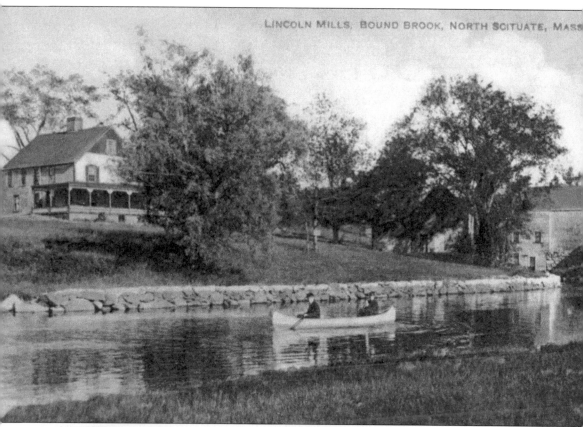

In 1691, blacksmith Mordecai Lincoln dammed the mouth of Bound Brook, holding back enough water to power his sawmill for two consecutive days each week. Hoping to achieve greater efficiency in his utilization of the brook, which turned to a mere trickle in the summer, he dammed it a second time upstream, and then a third time even farther up. He released the pool on Mondays and Tuesdays to power his iron forge; on Wednesdays and Thursdays it turned the grinding wheel of his gristmill; on Fridays and Saturdays he unleashed the brook's flow on his sawmill, from there finally letting the water drain into the Atlantic Ocean.

Lincoln's greatest contribution to American history came years after his death. By his wife Sarah Jones of Hull, Lincoln had two sons, Mordecai and Abraham. Young Mordecai moved to the Province of Pennsylvania, where he and his wife had five children, one of whom, John, moved to the Shenandoah Valley in Virginia. John's son Abraham moved to North Carolina and then Beargrass Fort, Kentucky, where he had three sons. Nancy, the wife of Thomas Lincoln, gave birth to a baby boy on February 12, 1809, who grew up to be Abraham Lincoln, the 16th president of the United States.

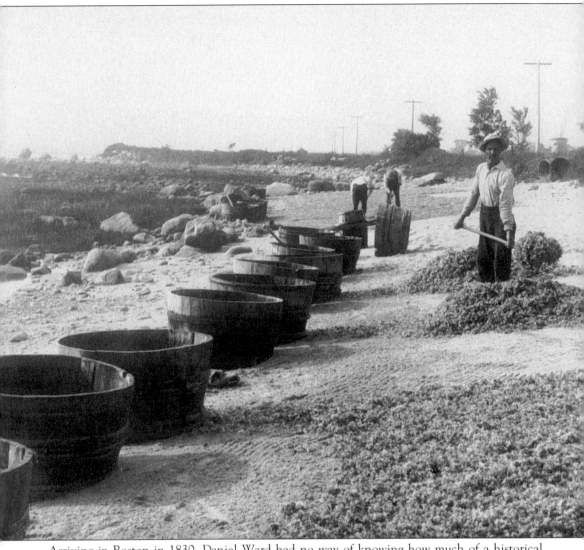

Arriving in Boston in 1830, Daniel Ward had no way of knowing how much of a historical impact he would make on the little coastal town of Scituate. Starting out in the fisheries in partnership with Myles O'Brien, Ward moved to Scituate in 1847, lured by its nearness to some of the state's best fishing grounds. Ward soon discovered deposits of *chondrus crispus*, a species of marine algae known as Irish moss or carrageen, growing on rocks off the Scituate shore. Familiar with it from his days in the west of Ireland, and knowing of its market potential, Ward began to collect the moss, encouraging other fellow countrymen to do so as well. Heading off the beach in small dories at slack tides, the mossers used 14-foot-long rakes to scrape the moss off the rocks and haul it into their boats. Bringing it ashore, they washed it in salt water, as fresh water would destroy it, and lay out on the beach to dry. When it had gone from slimy and black to brittle and white, the moss was ready for sale as an emulsifier, used in chocolate milk, toothpaste, mayonnaise, salad dressing, cosmetics, and various other items. Describing the beauty of the life of a mosser, one anonymous Scituate gentleman told *American Magazine* in 1942, "It's a great farm we have out there. We don't have to plow it or plant it, but it gives us four crops a season."

Block ice was necessary to keep perishables in the summer. The ice was stored in large icehouses like this one on Morris' Pond (also known as Echo Lake) with sawdust between the blocks for easy removal when needed. In summer, when the iceman made his deliveries, he would cut it to size for the waiting housewife to put in her ice chest.

Morris' Pond at North Scituate was drained after young David Bailey nearly drowned when he fell in, having to be rescued with an ice hook and rolled over a barrel to be revived. As owners, the Totman family did not want to take the chance of such an incident happening again and, as the need for ice had sharply fallen, they allowed both the icehouse and then the dam to fall into disrepair.

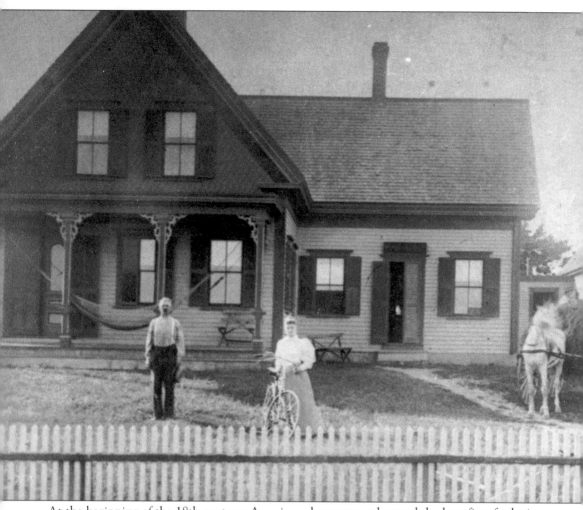

At the beginning of the 18th century, Americans began to understand the benefits of relaxing the body and mind when feeling sick. The country had been founded on hard work, from dawn to dusk, with busy hands forever turning the soil. America's first "vacations" consisted of getaways for acceptable reasons, either to revive the soul, at say, Chautauqua, or the body, at Saratoga Springs. Relaxation became a permanent fixture of American life after the Civil War, when the Industrial Revolution created a moneyed class that earned enough to afford summer cottages. Changes in architecture reflected the new attitude, as porches suddenly popped up around old colonial homes, and became standard features of Victorian style. This house on First Parish Road typified that moment of crossover. A hammock on the porch signifies rest, while the wagon of hay at the right reminds us of our country's agrarian beginnings. But of course this house today reminds us of an entirely different kind of rest: the permanent kind. It is the Richardson-Gaffey funeral home.

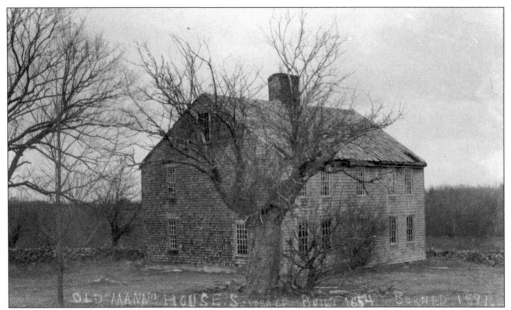

Richard Mann of the 1646 Connihasset partners built his farm with the ocean to the east and Musquashcut Pond to the north, near what is known as Mann Hill. This house, for which Mann Lot Road is named, was built in 1654 and burned down in 1891.

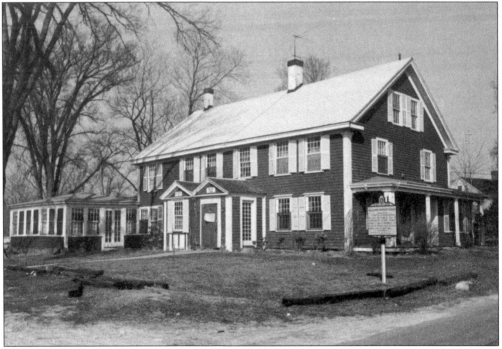

Yet another historic treasure is the Williams-Barker House, now a very successful restaurant. John Williams built the original house in 1634 on a 200-acre land grant. It was a garrison or place of refuge during King Philip's War. Still to be seen are the hand-hewn beams and the wide floorboards. Some say one of the huge fireplaces contains a space where people could hide in case of attack. There even may have been an escape tunnel.

The house at 642 Country Way served as the home for Rev. Albert D. Spaulding, pastor of the First Baptist Church during the 1890s and a longtime tax collector for the town. After retiring from the pulpit, he became a publisher, giving his business the name Bound Brook Press.

The bakery shop seen on the left in this view of Gannett Street burned down in 1907. On the other side of James Otis' barber shop is Ed Wentworth's multipurpose building, with a carriage- and sign-paint shop and a blacksmith shop on the first floor and, above, a wheelwright shop. The long ramp on the far right accommodated the carriages. Ducks did not normally wander the streets of Scituate; this group had just broken loose from James Otis' place.

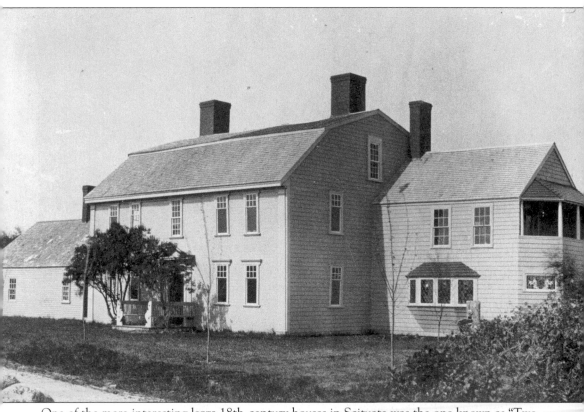

One of the more interesting large 18th-century houses in Scituate was the one known as "Two Stacks." This two-and-one-half-story mansion was built by Capt. David Little between 1700 and 1703, receiving its name from the two large chimneys at either end of the main house. Situated at the top of Booth Hill on Mann Lot Road, ship captains at sea used the house as a landmark. Captain Little's son, Barnabas, inherited the house and shared it with his sister, Mercy. Barnabas is best remembered as being very active in town affairs and instrumental in providing funds for Revolutionary War activities. Known for hospitality, the interior was described as welcoming, with its huge 8-foot fireplace, large ceiling beams, and exquisite polished cabinetry. The last owner, prominent Boston architect Edgar Allen Poe Newcomb, eventually settled in Hawaii. Even in Hawaii, however, he signed himself "Still Master of the Two Stacks." In later years, Two Stacks suffered from neglect, and eventually burned down.

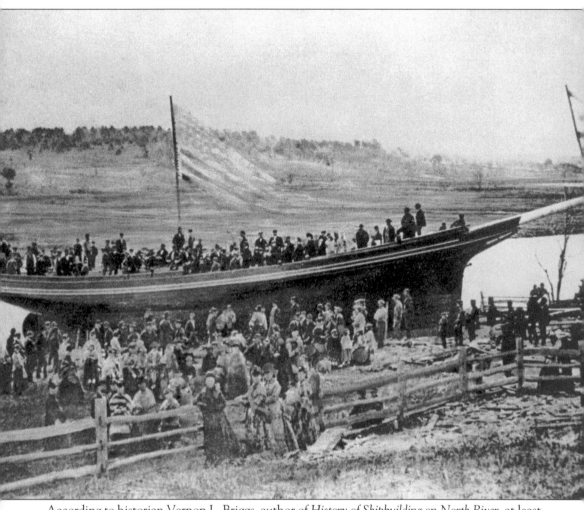

According to historian Vernon L. Briggs, author of *History of Shipbuilding on North River*, at least 1,025 ships were built and launched from shipyards on the North River between the 1650s and the 1870s. Tall trees, nearby pockets of bog iron ore for forging nails and anchors, and miles of access to the sea made the North River the perfect site on which to build ships during the formative years of the American republic. From the various shipyards, many famous vessels were launched, including the *Beaver*, from which Patriots dressed as Native Americans threw boxes of British tea into Boston Harbor, in the incident that became known as the Boston Tea Party; the *Essex*, rammed by a sperm whale in the South Pacific in 1819; and the *Columbia*, the first vessel to circle the globe under the American flag and the first ship to cross the treacherous Columbia River Bar, which is considered by Lloyd's of London insurers even today as the most dangerous stretch of water in the world. Capt. Robert Gray named the river for his vessel. Shipbuilding on the North River died out in the middle of the 19th century as the growth of the city of Boston attracted the skilled artisans up the coast to the inner harbor there. In 1871, the *Helen M. Foster*, above, became the last ship to be launched on the river.

Yes, even the rocks at Scituate elicited romantic poetry: "Brown and seamed with veins of grey,/ Lies old Well Rock on the Hazard's Bay./ Here, ebb tide and dawn make a picture fair,/ Shining sands tinted with colors rare-/ Fishermen seeking their spoils afar-/ While a mellow glory lights rock and bar;/ Bare-footed urchins wild with glee/ Launching toy ships on a mimic sea." For the last four verses of this anonymously written poem, contact the Scituate Historical Society.

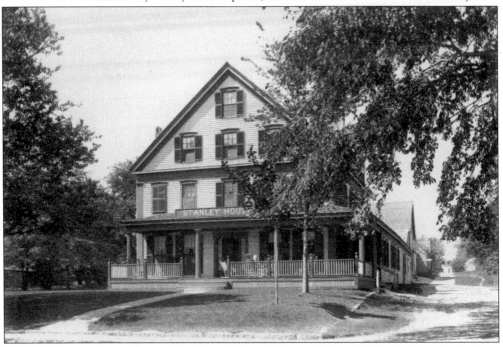

U.S. Life-Saving Service keeper Fred Stanley's son Thomas followed his father into the business of boats and breeches buoys, but his son William found that he rather enjoyed running a hotel. The Stanley House was located in the center of Scituate Harbor Village, described in one advertisement as "the ideal Old Colony town." Underselling his establishment, Stanley advertised it as "neat, comfortable, and well-managed."

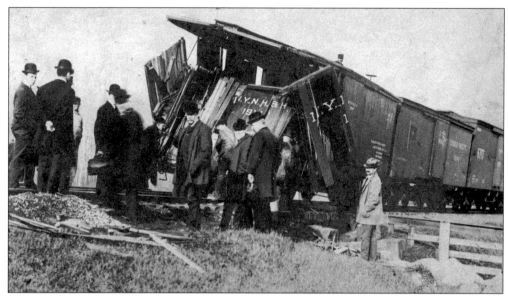

For all their advantages, trains often proved to be more dangerous than helpful. In 1890, one out of every 306 railroad employees died on the job, and one out of 30 could expect to receive an injury while at work. In one year, trains killed 330 people at grade crossings in Chicago alone. And accidents happened everywhere, as evidenced by this 1890s crash on the bridge over Bound Brook in North Scituate.

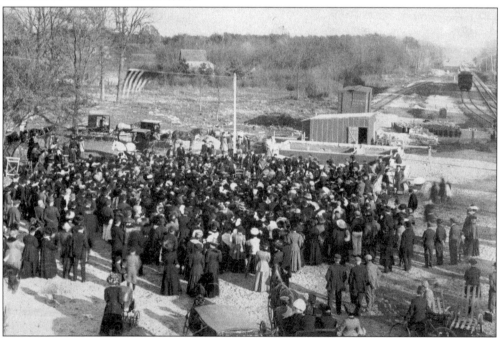

Nevertheless, Scituate's citizens still turned out in high numbers (1,200 in all) for the ceremonial laying of the cornerstone of the new North Scituate railroad station on November 10, 1909. Frederick T. Bailey placed a sealed copper box in the northwest corner of the foundation containing notes about changes to the roadways in the area and other local history, which still remains there, and a speech was given by—you guessed it—Henry Turner Bailey.

The salt hay collected in the marshes east of Little's Bridge and at other spots in town was highly prized as forage for animals, insulation, and in the early days, as thatch for roofs. This old-timer had all the tools necessary for a good day's work.

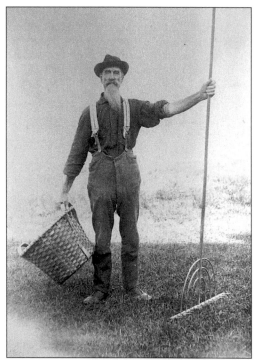

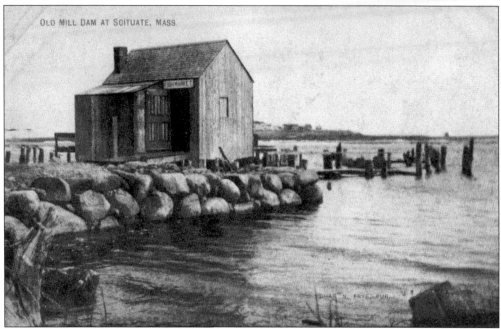

John Stetson erected a tide mill, which could be used all year, at Scituate Harbor in 1746. In the great snowstorm of November, 1786, the mill was swept across the marshes. The harbor did not have another grain and lumber mill again until 1802, when Jesse Dunbar built a mill on or near the same site. The last owner of the mill, John E.O. Prouty, bought the mill from Augustus Cole and D. Sanford Jenkins. Prouty continued the business until around 1890, when the building was moved and used by George Brown in his livery business.

On September 24, 1789, Pres. George Washington appointed the first five justices of the U.S. Supreme Court, among them 57-year old William Cushing, the chief justice of the Massachusetts Supreme Judicial Court. Cushing was born in Scituate on March 1, 1732, into a family with a long tradition of judges. Graduating from Harvard at age 19, he picked up the study of law, becoming a barrister in 1762. He practiced first in Scituate, and then moved to Pownalborough (now Dresden), Maine, which was then a province of Massachusetts. Over the next decade, he served as a judge of probate for the new Lincoln County, on the Superior Court of Common Pleas for Plymouth County and on the Supreme Judicial Court. The following year, at the outbreak of the American Revolution, he became its chief justice. In 1787, he attended the Massachusetts Constitutional Convention, serving as its president when John Hancock took ill. From 1789 until 1810, he served as an associate justice of the U.S. Supreme Court. Two memorials in town today remind us of his accomplishments, this one on Route 3A (Chief Justice Cushing Highway), and his burial plot off Neal Gate Street, the smallest state park in Massachusetts.

Out on the Driftway, along the North River, toil the employees of the Boston Sand & Gravel Company. Carrying the sand across the roadway by means of a conveyor, they would load it onto barges to be towed to the city for different filling projects, such as the construction of Logan International Airport in the 1930s.

Had the company looked to the North River as a site prior to the Portland Gate of 1898, they might have come to Scituate. The breakthrough of the river during that storm, however, shortened the passage to the sea by a mile. The land on which the Boston Sand & Gravel Company operated is now Conservation Park. The remains of the company's old pier can still be seen alongside the new one, and the mounded hill next to the parking area was built by the sifted sand washed in Hatherly Lake and carried across the road.

Poet Samuel Woodworth may have been sitting in a tavern in New York when he penned his most famous work in 1817, "The Old Oaken Bucket," but his heart had never left Scituate and his father's old homestead. His words longingly describe his desires for a return to the days of his youth, to a simpler time, when summer days provided freedom to explore and enjoy life at his own pace.

For a century and a half, school children around the world, from Canada to New Zealand, have memorized the words to Woodworth's poem, a work that has become an anthem for the town of Scituate.

The Old Oaken Bucket

by Samuel Woodworth

How dear to this heart are the scenes of my childhood
When fond recollection presents them to view;
The orchard, the meadow, the deep tangled wildwood,
The wide spreading pond and the mill that stood by it,
The bridge and the rock where the cataract fell;
The cot of my father, the dairy house nigh it
And e'en the rude bucket that hung in the well.
The old oaken bucket, the iron bound bucket,
The moss covered bucket, which hung in the well.

The moss covered bucket I hailed as a treasure,
For often at noon, when returned from the field,
I found it the source of exquisite pleasure,
The purest and sweetest that Nature can yield.
How ardent I seized it with hands that were glowing;
And quick to the white pebbled bottom it fell;
Then soon with the emblem of truth overflowing
And dripping from coolness it rose from the well.
The old oaken bucket, the iron bound bucket,
The moss covered bucket, arose form the well.

How sweet from the green mossy brim to receive it
As poised on the curb it inclined to my lips
Not a full blushing goblet could tempt me to leave it
The brightest of beauty or revelry sips.
And now far removed from that loved habitation
The tear of regret will intrusively swell,
As fancy reverts to my father's plantation,
And sighs for the bucket that hangs in the well.
The old oaken bucket, the iron bound bucket,
The moss covered bucket, that hangs in the well.

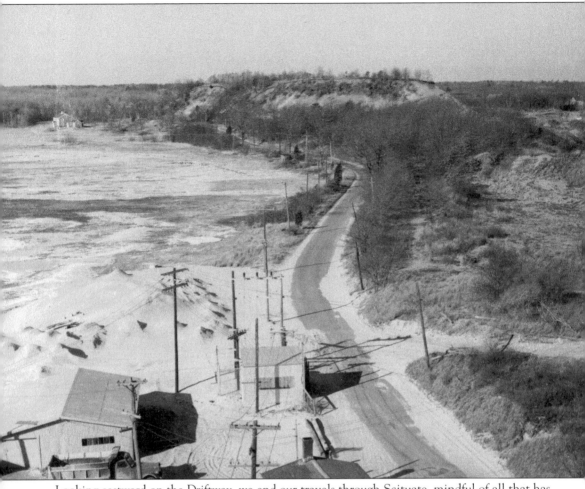

Looking eastward on the Driftway, we end our travels through Scituate, mindful of all that has withstood the test of time, yet keenly aware of the changes that have taken place atop the four cliffs, on the sandy beaches, and around the ponds, rivers, and brooks that make the town so special to us all. In this photograph, Frederick Damon's Museum at North Scituate is gone; at the top left, we see the Capt. Benjamin James House, built in 1739 and once used as a smallpox hospital, but now home to the Scituate Historical Society's Maritime and Irish Mossing Museum. On the right side of the road, the barren land on which many of the town's first settlers built their homes is now Widow's Walk Golf Course, heralded nationally as the prime example of environmentally conscious golf course design.

As we look to the future, we know that not every story will be remembered by all, and not every historic site will be saved. But we do know that the people of Scituate have always done and will continue to do their best to preserve the history of their community and proudly to share its unique richness with the rest of the world.

126

BIBLIOGRAPHY

If you have enjoyed reading this book, you will find even more of Scituate's fascinating history in the following books, all of which can be purchased at the Kathleen Laidlaw Historical Center, 43 Cudworth Road, Scituate, MA 02066.

Daughters of the Revolution. *Old Scituate*. Chief Justice Cushing Chapter, Daughters of the American Revolution, 1921.

Ball, David. *Night of Terror at Buoy No. 4: The Fairfax-Pinthis Disaster*. 1998.

———. *To the Point: The Story of Scituate Light and Cedar Point*. 1994.

Ball, David and Fred Freitas. *Etrusco: From Cradle to Grave*. 1995.

———. *Warnings Ignored! The Story of the Portland Gale of 1898*. 1995.

Bonney, Margaret Cole. *My Scituate*. Privately printed.

Briggs, L. Vernon. *History of Shipbuilding on North River*. Boston, Coburn Brothers, 1889.

Deane, Samuel. *History of Scituate, Mass*. Boston: James Loring, 1831.

Freymann, Jarvis. *Scituate's Educational Heritage*. Scituate Historical Society, 1990.

Hunnewell, Mary B., ed. *The Glades*. Privately printed, 1914.

Irwin, Will. *Scituate: 1636–1936*. Scituate Tercentenary Committee, 1936.

Murphy, Barbara. *Irish Mossers and Scituate Harbor Village*. Privately printed, 1980.

———. *Scituate: The Coming of Age of a Plymouth Colony Town*. Privately printed, 1985.

———. *The Life of Captain John L. Manson of Scituate*. Privately printed, 1989.

Pratt, Harvey H. *The Early Planters of Scituate*. Scituate Historical Society, 1929.

Valdespino, Stephen R. *Timothy Hatherly and the Plymouth Colony Pilgrims*. Scituate Historical Society, 1986.

The proceeds from the sale of this book will go to the restoration of the George W. Perry Post No. 31, Grand Army of the Republic Hall.

We hope that after reading this book you will spend time visiting the sites maintained by the Scituate Historical Society:

> Kathleen Laidlaw Historical Center, or the Little Red School House
> Cudworth House, Barn, and Cattle Pound
> Lawson Tower*
> George W. Perry Post No. 31, G.A.R. Hall
> Stockbridge Gristmill
> Old Oaken Bucket Homestead*
> Mann Farmhouse and Wildflower Garden
> Scituate Lighthouse*
> Scituate Maritime and Irish Mossing Museum*
>
> *denotes listing on National Register of Historic Places

For more information, please write or visit the Scituate Historical Society at P.O. Box 276, 43 Cudworth Road, Scituate MA 02066. 781-545-1083. On the Internet: http://www.ziplink.net/~history.